IMAGES
of Rail

YAKIMA VALLEY
TRANSPORTATION COMPANY

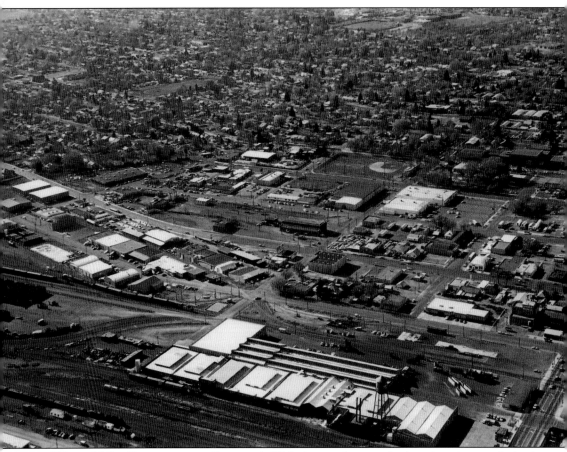

Yakima Valley Transportation Company's 1910 vintage shops and substation sit squarely in the middle of this aerial photograph taken in 1978. Motors A and 297 can be seen parked outside. Located at the southwest corner of Pine Street and Third Avenue, this complex has served the YVT railroad for over a century. (Photograph by Frederick A. Johnsen.)

ON THE COVER: Sumach Park was an early popular destination on the YVT. It was located at the end of the Maple Street line near the Yakima River. This was the jumping-off point for a planned but never built line to Moxee. Only the bridge piers for this extension were ever built. Car no. 8 is preparing to return to Yakima. (Photography by John C. Butterfield; courtesy Marionne E. Langemack.)

IMAGES
of Rail

YAKIMA VALLEY
TRANSPORTATION COMPANY

Kenneth G. Johnsen

ARCADIA
PUBLISHING

Published by Arcadia Publishing
Charleston, South Carolina

Printed in the United States of America

Library of Congress Control Number: 2010921998

For all general information contact Arcadia Publishing at:
Telephone 843-853-2070
Fax 843-853-0044
E-mail sales@arcadiapublishing.com
For customer service and orders:
Toll-Free 1-888-313-2665

Visit us on the Internet at www.arcadiapublishing.com

*This book is dedicated to my dear friend and helper, Ed Neel.
Ed's devotion to the Yakima trolleys is evident in the hundreds of
behind-the-scenes things he does daily to keep them alive. Whether
it's fixing a downed trolley wire in the middle of the night or being
the trolleys' goodwill ambassador to the community, no task is too
great and no request is ever turned down by this knowledgeable
and good-natured gentleman. Thanks, Ed, for being a key figure
in the history of the Yakima trolleys and for being my friend.*

CONTENTS

ACKNOWLEDGMENTS

I am indebted to many good people who have enriched the story of the YVT since the publication of *Apple Country Interurban* in 1979. Special thanks go to Yvonne Wilbur and John Baule of the Yakima Valley Museum for their generous help.

Former YVT lineman Dick Noyes played a crucial role in helping me save valuable YVT records that were almost lost. Fellow YVT enthusiast Hilding Larson provided needed esoteric details and great photographs as well as being the one who helped me begin my research on YVT when we were both still in college.

Others who have lent photographs or helped in some way, but sadly have passed on, include former YVT superintendent Oliver (Pat) Potter, Wray and Rosella Brown, Bob Lince, Robert S. Wilson, Ron Ott, Jerry Henderson, Al Farrow, Bob Jones, Walt Shoot, Mel Lucas, John and Muriel Ainsworth, Lawton Gowey, Charles Smallwood, Marionne E. Langemack, Bob Hively, Irene Hill, Barb Thompson, and Bob Leinbach.

Still more who have helped the project include Paul Edmondson, Warren Wing, my brother Fred Johnsen, Bob Sullivan, Bob Brown, Tony Wonders, Jerry Gieseke, Jeff Asay, Ben Alaimo, Ray Paolella, Ed and Scott Neel, Dorothy Siegmeth, James Harrison, Ed Maas, Charles Savage, Sarah Higginbotham and Devon Weston at Arcadia Publishing, and Rich Wilkens.

To reduce verbiage, photograph credits will either have the photographer's name or one of the following designations: KGJ is Kenneth G. Johnsen, AC is Author's Collection, YVM is Yakima Valley Museum, and RSW is Robert S. Wilson.

INTRODUCTION

No one would have guessed, when the Yakima Valley Transportation Company was incorporated in the summer of 1907, that it would outlive all of its contemporaries to become America's last intact example of early-20th-century interurban railroading. Hundreds of electric interurban lines were springing up all over the country in the early 1900s, and the YVT at that time was very much like all the rest.

Built with the remains and franchise of the failed Yakima Inter-Valley Traction Company, the YVT established public transportation in Yakima with a 3-mile line leading west along Yakima Avenue from the Northern Pacific (NP) main line to a point on what today is called Nob Hill Boulevard. In 1908, it headed east, crossing the NP and linking the east side of town with the west. Three new streetcars arrived in Yakima during the summer of 1908. Yakimans were justly proud of their electric line on the edge of the Washington desert.

Financial difficulties in 1908 and early 1909 culminated in the secret purchase of the YVT by agents of the Union Pacific (UP). Union Pacific was not particularly interested in getting into the streetcar business, but it had long been eyeing the Yakima Valley and was covertly building a line from the Columbia River to Yakima under the alias of North Coast Railway. Irrigation in the valley was opening up vast agricultural lands, and Union Pacific wanted to tap this new business. The YVT, if expanded into an interurban, would be the perfect vehicle to bring in carloads of produce to the Union Pacific railhead in Yakima. Yakimans did not know it at the time, but the purchase of the YVT by the Union Pacific in 1909 for freight purposes would ensure its longevity into the 21st century.

The YVT began to flourish as Union Pacific capital flowed in. Extensions were built along Fruitvale Boulevard and west toward Ahtanum and Wiley City. Interurban cars and locomotives were purchased, the first three arriving on July 1, 1910. The automobile had not quite taken hold, and so passenger revenues increased as new tracks were laid. During the weeks that the Washington State Fair was held in Yakima, the railroad was strained to capacity taking fairgoers from town to the fairgrounds.

In August 1910, an imposing stone and brick carbarn/shop complex was built on property at the corner of South Third Avenue and Pine Street. A high-tech (for 1910) belt-driven machine shop was installed, enabling the railroad to manufacture parts and things it needed to stay in operation.

Lines were further developed to a Bureau of Reclamation project at Harwood and on to Henrybro, or Gromore as it was also called. Vast farmlands were opening up in this area, and YVT was positioning itself perfectly to be able to handle the business. Union Pacific's archrival Northern Pacific had nothing comparable, and so the UP enjoyed a virtual monopoly.

By 1912, YVT had begun work on what would be its last major expansion, the line to Selah. Getting to Selah required crossing the Naches River and climbing through a narrow break in the hills called Selah Gap (along with the Yakima River, the Northern Pacific mainline, and

the old Yakima-to-Selah wagon road). To get through Selah Gap, a shelf was blasted out of the canyon wall along which YVT made its precarious crossing. A rare, second-hand Pegram Truss bridge was brought to the Naches River crossing in kit form from an earlier life in Manhattan, Kansas. The bridge, originally built in 1895, was reassembled over the Naches River in 1913 and is still in service today.

While freight service thrived, automobiles made significant inroads into YVT's passenger business as the teens turned to twenties. The wooden trolley cars purchased between 1908 and 1910 were starting to look bleak, cold, and uncomfortable compared to the passenger auto. In 1926, YVT negotiated an agreement with the city to allow it to substitute a bus for the streetcar on its Summitview line. The 29-passenger Mack bus no. B-1 was an instant hit and brought patronage back to the line. Encouraged, YVT bought two more buses and used them on other lines. The result was not nearly as good, and soon streetcars were running on their old routes again.

By 1929, patronage was down so much on all lines that YVT wanted out of the passenger business altogether. But the city would have none of that and told the railroad that the terms of the franchise required transit service wherever the freight trains went (within city limits). So in one last try at wooing passenger business, YVT purchased three shining new Master Unit cars from Brill and introduced them in March 1930. Like the B-1, the Master Units were an instant hit, and patronage surged—for a while. During World War II, ridership again lagged. By the time of the franchise renewal of 1946, the railroad wanted out of the passenger service so badly that it gave up its lucrative customer on the east side (Cascade Mill) and all track east of Sixth Avenue in exchange for being allowed to suspend passenger service. Final runs were held on February 1, 1947.

The interurban lines had similarly suffered from declining numbers of riders in the late 1920s. Sometimes there would be only one or two riders on the whole trip to Selah. In 1934, YVT applied to the state and county to discontinue interurban passenger service. A hearing was held, attended by angry townspeople demanding that the service continue. One of the examiners asked for a show of hands how many people had come to the meeting by trolley. Only two hands went up, and so permission to discontinue the service was granted. May 15, 1935, saw the last interurban run—performed by motorman J. Wallace Estes and carrying only enthusiast Robert S. Wilson.

Freight business on YVT continued to grow. Originally, the express motors nos. 300 and 301 pulled a few cars of freight each. In 1914, they were supplemented with the purchase of a second-hand locomotive from the Oregon Electric Company, no. 299. Always a lightweight, the 299 had insufficient traction for the growing volume of freight. By 1920, YVT handled 5,708 cars of apples alone. In 1922, the railroad purchased a brand new 50-ton steeple cab locomotive from General Electric, no. 298. For the next 63 years, this faithful motor handled the lion's share of freight duties for the YVT.

YVT wasn't Union Pacific's only electric railroad. UP had purchased the electric Glendale & Montrose railroad in Southern California and found it feasible to dieselize that line. The Glendale & Montrose boxcab motor no. 22, built by Baldwin-Westinghouse in 1923, was transferred up to Yakima in 1942, where it became YVT no. 297. The 297's cab was not as easy to work from as the 298's, so the 298 was the favored power among crews.

From 1948 through the end of freight service, dieselization was proposed for the YVT no fewer than six times. Each time the reasons of personnel economy and elimination of catenary maintenance were cancelled out by the greater cost of the diesel and its fuel over the paid-for electrics and their cheap electricity. Finally, in 1983, a diesel was purchased. But the reasons were not the same as before.

The franchise renewal of 1983 spelled out times when the YVT trains could be out in the middle-of-the-street track, and this limited the railroad's ability to provide the personalized customer service it was famous for. "Safe Streets" committees had petitioned the city not to even renew YVT's franchise. The city compromised by limiting the railroad's operations to non-rush hour times. In order to be able to get around this curfew, the railroad purchased a Whiting Trackmobile. This machine, it was planned, could drive on the roads with its rubber tires during

the blacked-out times and bring freight cars back into town on rails after hours.

Upholding YVT's tradition of numbering locomotives in descending order, the Trackmobile was numbered YVT 296. It proved to be a failure. It was even lighter than the old locomotive 299 had been and could only pull about two cars up some of YVT's hills. But by 1983, time was running out for the railroad, and in 1984, UP applied to abandon all freight service on the YVT. Permission was granted by the Interstate Commerce Commission, and on a cold November 18, 1985, ceremonial final runs were made over the entire system (by this time approximately 21 miles). Both the 297 and the 298 were operated, and the Trackmobile stayed conspicuously out of the celebration.

Union Pacific officials, YVT crewmembers, members of the press, trolley coordinator Barb Thompson, and the author participated. A token last refrigerator car of apples from Congdon's orchards was brought back into town. At Wide Hollow Junction, an official portrait was made of the two motors on their last day. Following abandonment, the 296 and 297 were lifted onto flatcars bound for California. The 296 would continue its meager existence in the Bay Area, and the 297 would go on display at the Orange Empire railroad museum in Perris, California.

Union Pacific donated the remaining YVT locomotives, line car A and steeple cab 298, to the City of Yakima along with the entire railroad and overhead power distribution system. It leased the carbarn property to the city, because the land still had considerable value. Even so, the railroad wrote off $1.2 million with the gift and didn't have to stand the expense of tearing the railroad up. (In 2008, the city was able to purchase this final part of the system.)

The reason for Union Pacific's gift lies in another facet of YVT's life that is the reason why the antique railroad is still with us today. After watching the city and the YVT go through a long, protracted franchise fight from 1971 to 1973, the author decided to propose that they both make something positive out of the railroad and bring back passenger trolley service. That proposal was made to the Yakima City Council on February 5, 1973, and Councilman Wray Brown liked the idea. Immediately, he and the author set out to find trolleys for this new tourist-oriented service.

A search by this writer of all the trolley museums in the United States turned up only one (wrecked) car that was available. Two of the former YVT Master Units were operational at the museum in Snoqualmie, Washington. However, the owner did not wish to sell his cars and Brown didn't think they looked "old" enough. Finally, Paul Class, curator of a trolley museum in Oregon, said he could get some vintage trolleys that were still running in Oporto, Portugal. Armed with letters of introduction from Yakima's mayor, Class was sent to Portugal to negotiate the purchase of two cars.

Meanwhile Brown, an able politician, utilized his connections to get letters of support for the trolley project sent to Union Pacific president John Kennefick. Even Washington governor Dan Evans wrote a personal letter to Kennefick, and that seemed to do the trick. With Kennefick's blessing flowing down through the chain of command, the once-recalcitrant railroad suddenly took on an air of "how can we help?"

Although the road from Oporto to Yakima was fraught with mystery, intrigue, and botched instructions, the two trolleys finally arrived in Yakima on August 28, 1974. Over the next few months, they were tested and motormen were recruited and trained from among off-duty firemen. By October, all was ready, and on Columbus Day, 1974, President Kennefick flew out from Omaha to motor the first trolley on the line. It was a grand and gala time, and for days thereafter, the trolleys operated in tandem with standing-room-only crowds.

A group of ladies from the Sweet Adelines singing group organized a subgroup called the Trolley Dollies. They created early-20th-century costumes and rode each trolley run to give a running commentary on the sights passing outside the trolley. Patronage was heavy for a number of years, and the trolleys truly did accomplish their objective of turning the railroad into something positive for the community.

The Visitors and Convention Bureau was in charge of trolley operation but decided to quit after the 1982 season, so a nonprofit group, the Yakima Interurban Lines Association (YILA), was formed in 1983 to take over trolley operation using an all-volunteer workforce. Jerry Henderson

became its president. The author attempted to get the railroad listed on the National Register of Historic Places, but the Union Pacific blocked it. After the Union Pacific abandoned the railroad and gave it to the city, the National Historic Register listing was obtained.

In the middle 1990s, grants were obtained to rehabilitate the YVT through the ISTEA (Intermodal Service and Transportation Efficiency Act) program. Alleged irregularities in handling the grants, as well as other problems, caused relations between YILA and the city to deteriorate in the 1990s. Things became so strained that in 2000, the city erected barricades around the trolley barn and evicted the YILA officials.

A new organization was set up, with the city's blessing, called the Yakima Valley Trolleys in 2001. Its membership has grown steadily over the past decade as it faced new problems unheard of in the past. In 2005, the price of copper climbed to an all-time high, and thieves began cutting down YVT's overhead and feeder wires so that they could take the wire to recyclers and get money to feed their drug habit. This temporarily shut down the Selah run and restricted trolley operation to Pine Street. As of this writing in March 2010, replacement wire has been obtained, an alarm circuit for the overhead wire system has been developed, and the group is ready to begin restringing wire.

The new trolley organization has dreams of running track back up Yakima Avenue to the heart of town as well as out to the Yakima Valley Museum on Tieton Drive. The little interurban railroad on the edge of the Washington desert has survived for over a century, and prospects for its second century look bright.

One

EARLY DAYS

Early attempts to build a street railroad in North Yakima (as Yakima was then called) failed for lack of capital. The most ambitious scheme had its start in June 1906, when a group of real estate developers met at the Commercial Club and established the Yakima Inter-Valley Traction Company.

Stock was to be sold locally. Much publicity surrounded the stock sales, and trustee William Sawyer visited towns around the valley to promote the scheme. Local newspapers told of eastern capitalists who supposedly visited and proclaimed Yakima's street railroad an excellent investment.

The Yakima Inter-Valley Traction Company got its franchise on October 15, but slow stock sales prevented it from buying materials. By the following summer, the group turned to A. J. Splawn and financier Alexander Miller to bail them out. The franchise specified 3 miles of track had to be in operation by January 1, 1908, and 7 miles by January 1, 1910.

A new corporation was formed, Yakima Valley Transportation Company (YVT), and its first official meeting was convened July 2, 1907. To get fully subscribed stock, the new corporation traded half its stock for the assets and franchise of the earlier company and then had only half as much to sell. Splawn was elected president, and he vowed to complete the railroad even if it meant getting outside capital.

Splawn's right-hand man, George Rankin, became general manager of the YVT. With more money finally coming in, Rankin made a trip to the coast. He obtained a used motor-generator in Seattle and rented two streetcars from Tacoma Railway & Power Company.

By December 22, track was laid and the streetcars had arrived. Tacoma car no. 18 made the very first test run that day, followed by car no. 36. On Christmas Eve, 1907, Jack Splawn gave the YVT directors and the city council an inaugural ride on streetcar no. 18. The railroad saved its franchise! The line was described as "smooth as glass" by reporters. Public rides began Christmas Day. The first 3 miles had started on Yakima Avenue just west of the Northern Pacific tracks and went west. Work began immediately on the next 3 miles, which went east on Yakima Avenue.

WILL BUILD TEN MILES OF ELECTRIC RAILROAD

D. E. GOULD OF BOSTON MAKES GOOD OFFER

Application for Franchise Contains Many Good and Businesslike Features—May Be Amended Slightly.

Speaking of his application for an electric street railroad franchise, D. E. Gould, of Boston, appears to be a broad minded, careful man, fully aware of the significance his prospective investment means for the city. Mr. Gould talked very freely to a representative of the Herald, and in the course of his remarks, he said:

"In making application for a franchise to build and operate a line of street and suburban railroads in this city the public will naturally be interested in learning something of such railroads.

"So far as I may be permitted at this stage of the proceedings I am perfectly willing to take the public into my confidence.

"It is obvious that in order to build such lines of railroad it will be necessary that the terms and conditions of the franchises to be obtained at the hands of the city government and county commissioners should both be acceptable; as either would be worthless without the other. It would...

...courage such ideas than the east because of its greater capital requirements in the future for necessary developments.

The offer to put up $5,000 would safeguard the city's interests, and as that amount would be forfeited to the city in case of failure to build the road, it would seem to answer the question as to the good faith of the prospect."

Following is the wording of the franchise Mr. Gould asked for at the council meeting Monday evening:

An Ordinance granting unto David E. Gould of the City of Boston, Massachusetts, and to his heirs, successors and assigns, the right, privilege and franchise of building, constructing, maintaining and operating upon the streets, thoroughfares and public places of the city of North Yakima, Washington, a system of railroads whereon to transport passengers, freight, mail, baggage and express, and to charge...

Promoters of a street railway for Yakima tried to drum up local financial support for the enterprise. When local money was not forthcoming, it became necessary to give a little encouragement in the form of praise for the Yakima project from well-heeled eastern financiers. One "D. E. Gould of Boston" even visited the city council and asked for a franchise and then promptly disappeared. (AC.)

Andrew Jackson Splawn, a stockholder in the stillborn Yakima Inter-Valley Traction Company, became the president of successor corporation Yakima Valley Transportation Company. The earlier company could not sell enough of its stock to buy materials. (Yvonne Wilbur collection.)

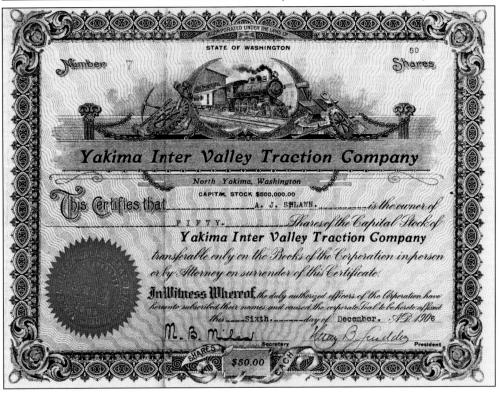

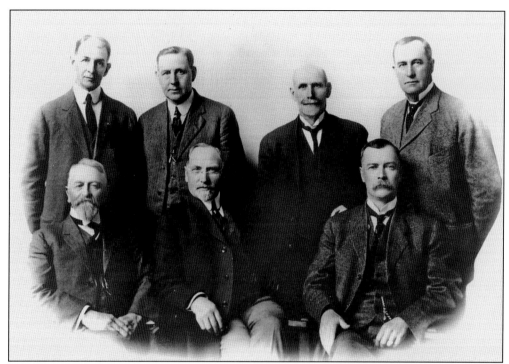

The people who ultimately put together the YVT and launched the railroad in 1907 posed for this formal portrait. From left to right are (seated) A. J. (Jack) Splawn (president), Alexander Miller, and George S. Rankin (general manager); (standing) James O. Cull, A. E. Larson, William P. Sawyer, and Dr. Cyrus G. Fletcher. (Fred Erickson collection.)

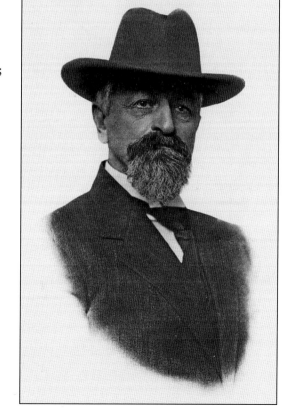

Andrew Jackson Splawn was the guiding light behind the Yakima Valley Transportation Company from its beginning. He oversaw every detail in its formation and construction, and George Rankin carried out the work of obtaining materials and getting it built. Splawn was rarely seen without his Stetson hat. (AC.)

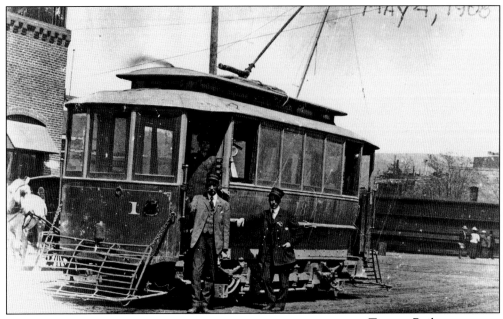

MAY 4, 1908

ELECTRIC STREET RAILWAY.
TIME TABLE.

Westbound.		Eastbound.
6:30 a. m.	6:50 a. m.
7:10 a. m.	7:30 a. m.
7:50 a. m.	8:10 a. m.
8:30 a. m.	8:50 a. m.
9:10 a. m.	9:30 a. m.
9:50 a. m.	10:10 a. m.
10:30 a. m.	10:50 a. m.
11:10 a. m.	11:30 a. m.
12:00 m.	12:15 p. m.
12:30 p. m.	12:45 p. m.
1:10 p. m.	1:30 p. m.
1:50 p. m.	2:10 p. m.
2:30 p. m.	2:50 p. m.
3:10 p. m.	3:30 p. m.
3:50 p. m.	4:10 p. m.
4:30 p. m.	4:45 p. m.
5:00 p. m.	5:15 p. m.
5:30 p. m.	5:45 p. m.
6:00 p. m.	6:15 p. m.
6:30 p. m.	6:50 p. m.
7:10 p. m.	7:30 p. m.
7:50 p. m.	8:10 p. m.
8:30 p. m.	8:50 p. m.
9:10 p. m.	9:30 p. m.
9:50 p. m.	10:10 p. m.

N. B.—The first two trips are not made on Sundays.

This time table is subject to change without notice.

[left column fragments]

ts

gy, worth
m., at 302

ge on car
erms. St.
20-tf

1s.

n Capitol
ms. Lock
27-tf

Black Re-
1. R. M.
26tf

orse, new
harness,
safe for
cost $300.
; 302 So.
22tf

or deliv-

Tacoma Railway & Power Company streetcar no. 18 made Yakima's first streetcar test run on December 22, 1907. It also ran the inaugural special run on Christmas Eve, 1907. It and Tacoma car no. 36 were rented from December 5, 1907, to October 22, 1908, and served the YVT until its own new cars arrived. (YVM.)

YVT's very first published timetable shows the trip took 20 minutes each way on the initial 3 miles of track. (AC.)

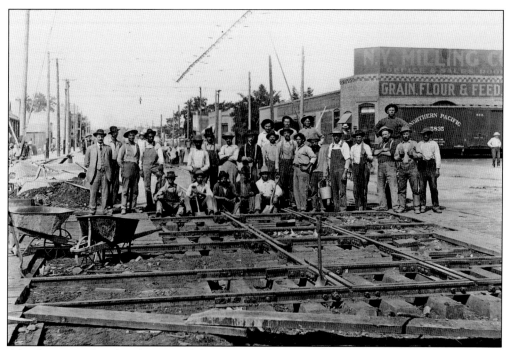

After laying its first 3 miles west of the NP main line in 1907, YVT built its line east in 1908. During the summer, crossing diamonds over five NP tracks were installed (all at YVT expense), and the trolley railroad advanced eastward into the heart of town. This photograph gives a rare glimpse to the west on Yakima Avenue. (Pat Potter collection, courtesy Robert Lowry.)

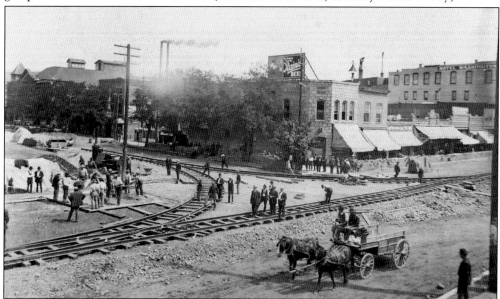

Throughout the summer of 1908, construction proceeded eastward on Yakima Avenue. The photograph shows a wye that was built at Front Street. This line went north two blocks, then east two blocks, then south two blocks to rejoin Yakima Avenue. It was called the Courthouse Loop and formed the turnaround point for several lines. The man standing in the middle of the track, in a Stetson hat, is Pres. Jack Splawn surveying the progress. (YVM.)

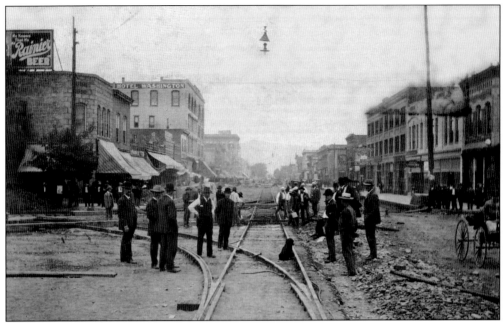

From the wye at Front Street, YVT's line continued east along Yakima Avenue. Among the spectators watching the progress is YVT president Jack Splawn, standing to the left wearing his signature Stetson. The arrival of YVT's first three new streetcars was a couple of months away. (YVM.)

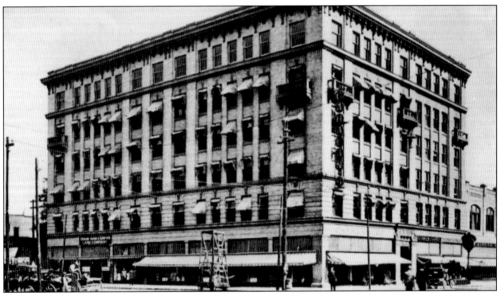

YVT director Alexander Miller built Yakima's most imposing office building at the corner of Second Street and Yakima Avenue in 1907. The YVT line advanced past the Miller Building in the summer of 1908. The homebuilt tower car in front of the building was used by YVT until 1922 to string up trolley wire. (Ron Ott collection.)

Two

EXPANSION INTO AN
INTERURBAN RAILROAD

Robert Strahorn was a railroad builder who secretly snuck the Union Pacific (Oregon Railway & Navigation Company) into the Yakima Valley under the alias of North Coast Railway. He also covertly pushed UP's line into Spokane. Because everything he did was accomplished under the cloak of secrecy, Strahorn became known as the "railroad sphinx."

YVT's stock subscriptions lagged in late 1908, and Splawn and Rankin could see that in order to meet the terms of their franchise, they were going to have to get outside help. They met secretly with Strahorn and had no difficulty convincing him that the YVT could become a freight feeder to the Union Pacific when UP reached Yakima some two years hence.

Strahorn dispatched a young lawyer working for the Union Pacific in Baker, Oregon, named Nathan C. (Nick) Richards. Characteristically, Strahorn tore the top letterhead off the letter he sent Richards instructing him to go and buy the YVT so that his employer would remain anonymous.

YVT fell under UP ownership on June 9, 1909. Almost immediately, the effects were felt. Interurban line construction pushed ahead, new rolling stock was ordered, and more people were hired. Over the next four years, the railroad grew to its largest size of about 48 track miles. Three major branches were built into agricultural lands: Wiley City, Henrybro, and Selah.

At first, passenger service was promoted. However, as the automobile gained in popularity, ridership went down, and ultimately passenger operations were discontinued on the interurban lines in 1935. But freight service on the three lines would thrive for another 50 years after that, thus ensuring the YVT would survive when all its contemporaries disappeared.

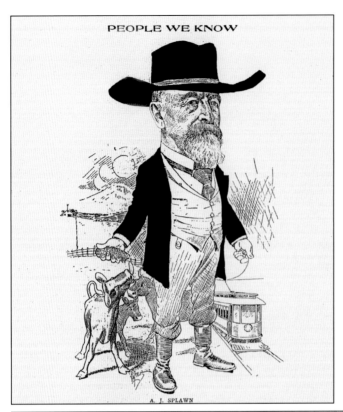

PEOPLE WE KNOW

A. J. SPLAWN

Jack Splawn was the man of the hour in 1908. The *Yakima Republic* covered its front page with this bigger-than-life depiction of him to celebrate his diverse activities: railroad president, friend of the Indians, livestock raiser, irrigation promoter, Yakima mayor, and almost state governor in a close 1908 election. (Yvonne Wilbur collection.)

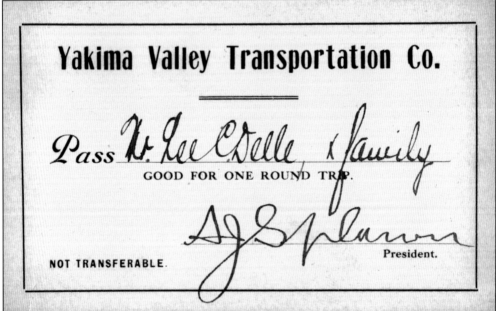

Yakima Valley Transportation Co.

Pass *W. Lee Odelle, & family*

GOOD FOR ONE ROUND TRIP.

NOT TRANSFERABLE.

President.

Splawn's signature on this YVT pass dates it to some time in 1908 or early 1909, before the takeover by the Oregon Railway & Navigation Company (Union Pacific). Although Splawn would continue to serve on the YVT board of directors, Nick Richards became president under the new regime. (Scott Neel collection.)

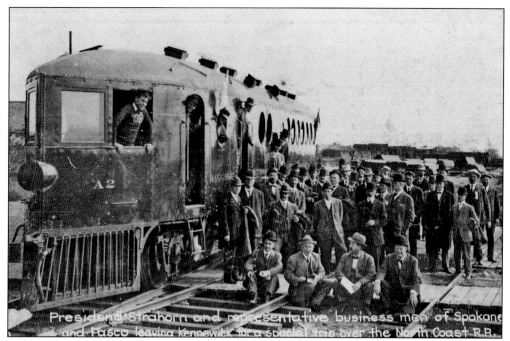

The man behind Union Pacific's takeover of the YVT was Robert Strahorn. Always secretive about who was backing him, Strahorn was able to get key rights-of-way for his employer so that the UP had an advantage getting into Yakima and Spokane. In this photograph, he is seen giving the businessmen of Spokane a tour of the railroad he was building. (YVM.)

YVT's franchises required that passenger service be provided wherever the freight lines went, which is why a waiting station sits forlornly out in this agricultural district at the end of the Fruitvale line near Powerhouse Road. This was one of YVT's first extensions when Union Pacific money started flowing in, and the reason is obvious. (AC.)

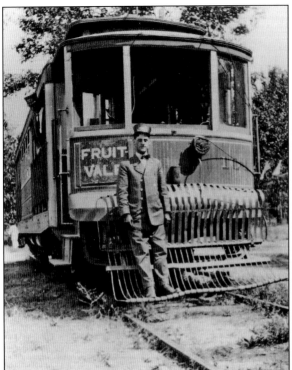

In 1910, automobiles were still scarce enough that the YVT invested in a sightseeing car, no. 101. Called the "Seeing Yakima Car," the 101 could be closed in the winter or open with bench seats in the summer. Its use was primarily for tours and charters. (Rich Wilkens collection.)

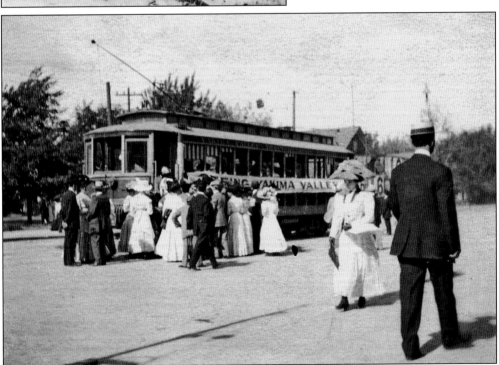

If one had 50¢ and three hours to spare on a summer Sunday afternoon, one could ride the "Seeing Yakima Car" and tour the entire YVT railroad. The car also made pleasure trips to the Hippodrome, an amusement park near Selah, and could be chartered for picnics and events. (YVM.)

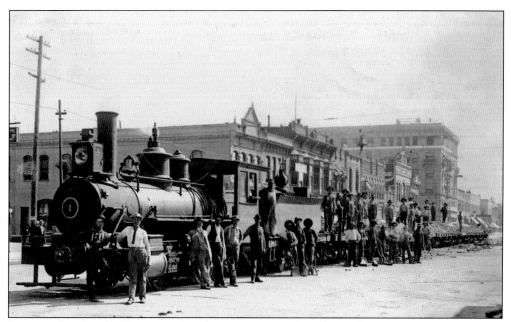

Two months after the Union Pacific takeover, YVT purchased a small 0-4-0 type steam engine to help with track building in places where overhead wire was not yet strung up. This photograph shows it on Yakima Avenue in 1909 helping with the laying of a second track down the avenue. (George M. Martin collection.)

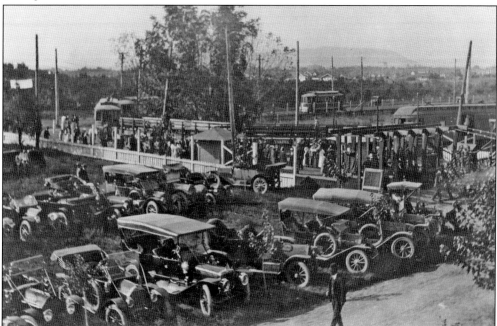

One of the earliest lines to be completed went to the Washington State Fairgrounds in 1909. This Fairview line had a reverse loop at the fairgrounds with a set of private entry gates for trolley riders. Fair week was by far YVT's busiest time of the year. All streetcars were pressed into service, and even flatcars with benches were pulled by freight motors to bring people to the fair. (Bob Lince collection.)

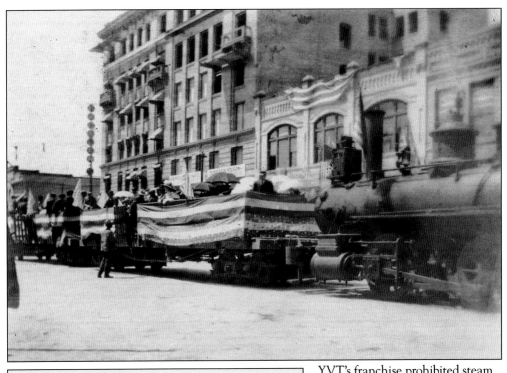

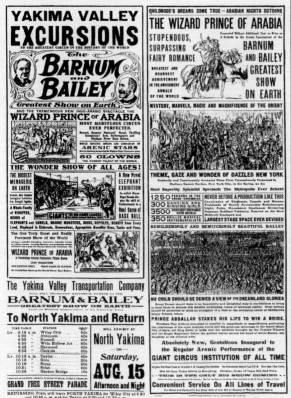

YVT's franchise prohibited steam locomotive operation on city streets except for construction purposes. During fair time, every available piece of motive power was pressed into service to carry fairgoers out to the fair. Presumably the city looked the other way as YVT steam engine no. 1 pulled flatcars of celebrants past the Miller Building in 1910. (YVM.)

Circuses also provided the YVT with extra business. Barnum and Bailey even printed the interurban cars' schedule on their posters. The florid text reaches a level of hyperbole not seen in advertisements today. The circus grounds were on the Maple Street line, where the Washington Junior High School is located today. (AC.)

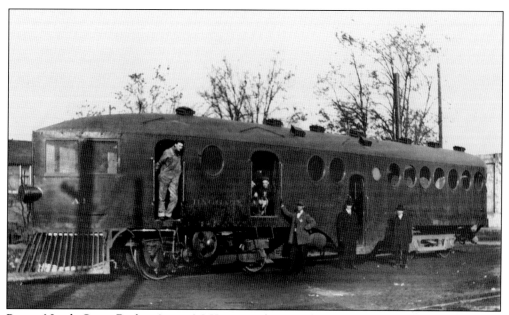

Parent North Coast Railway's two McKeen gasoline mechanical cars opened the Wiley City line on June 17, 1910, and were used for a while before the arrival of the electric interurban cars and before the overhead wire was completed beyond Ahtanum. Because they were noisy and rough riding and difficult to turn around in town, crews were happy to be rid of them when the electrics came. (YVM.)

After the arrival of the electric interurban cars in 1910, the North Coast Railway McKeen cars went into service on the North Coast to towns in the lower Yakima Valley. Car no. A-1 is seen here with an admirer ready to depart the Yakima yards. (AC.)

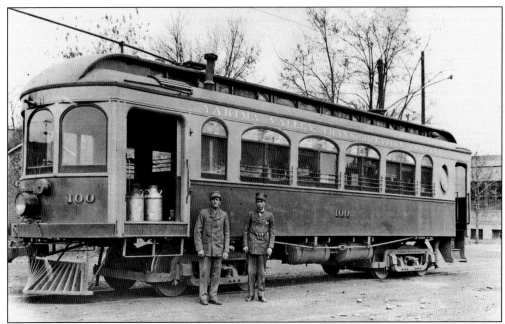

All of YVT's cars were painted standard yellow in the beginning. Attractive Niles car no. 100 arrived in Yakima on July 1, 1910. It is shown here with motorman Otto Peske (left), who lived to attend the inauguration of renewed passenger service on the YVT in 1974. The 100 car was purchased for the Ahtanum/Wiley City run. (AC.)

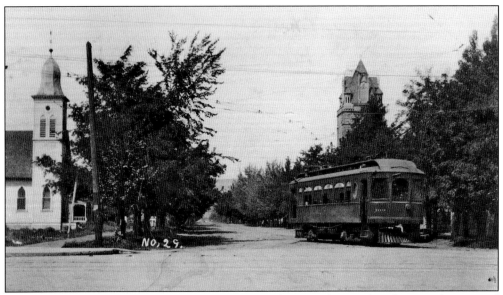

North Fourth Street was one of the first lines pushed to completion after the UP takeover and was also the first line to be abandoned when passenger ridership declined. Here Niles interurban combination baggage-passenger car no. 100 turns onto North Fourth Street from Yakima Avenue. The terminus of the Fourth Street line was plagued with bandits who robbed passengers and motormen alike. (Ron Ott collection.)

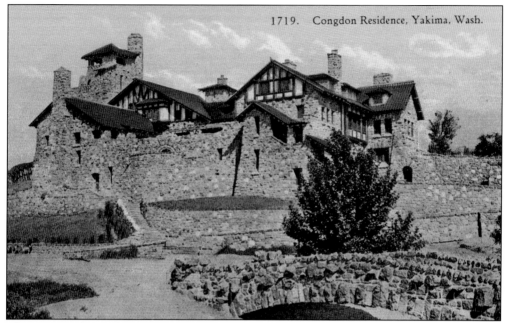

1719. Congdon Residence, Yakima, Wash.

Chester Congdon and his wife built a palatial mansion on their 600-acre orchard west of Yakima, which they used for a summer home. They came from Minnesota, where they had made a fortune in iron and steel (one detractor said, "she would iron and he would steal!"). Congdon disliked the YVT going through his property and grudgingly gave a reversionary easement to the railroad that required freight service or the land would go back to the Congdons. (AC.)

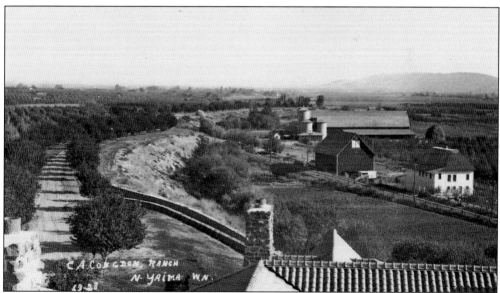

Congdon's castle was built with rock from Cowiche Canyon, hauled via YVT from the end of the Fruitvale line to the castle on the Nob Hill line. This view from the mansion shows the YVT track cutting across the estate. When freight service ended on YVT in 1985, Congdons reclaimed the right of way, and thus one property owner caused the demise of all of the western lines of the YVT. (YVM.)

25

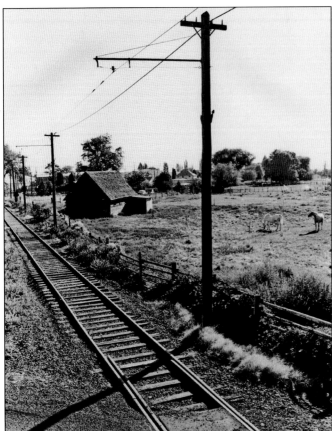

YVT's lines to both Wiley City and Henrybro encountered fewer orchards and more open farmland the further west from town they went. The track here has just rounded the bend in Ahtanum and is headed out across the fields to Wiley City. YVT track used 60-pound rail on untreated ties. (KGJ.)

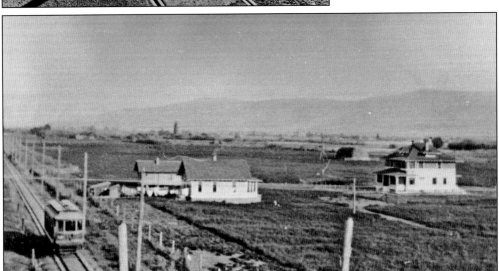

The "Seeing Yakima Car" no. 101 rolls into Wiley City. Speed limits on the interurban lines were 40 miles and hour and on city lines 30 miles an hour. The 101 car no longer visited Wiley City after 1929. From 1974 to 1985, Oporto trolleys again brought sightseers to Wiley City, but today the tracks are gone, and only the large house on the right remains from this scene. (Bob Lince Collection.)

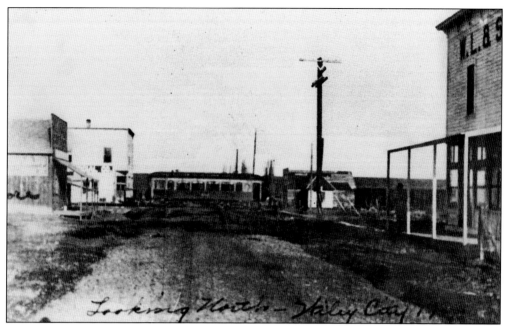

This is the earliest known photograph of a YVT car in Wiley City. Combination car no. 100 has just arrived. Starting in the summer of 1916, an auto stage service began meeting the interurban cars and taking passengers out to Tampico. (Jerry Gieseke collection.)

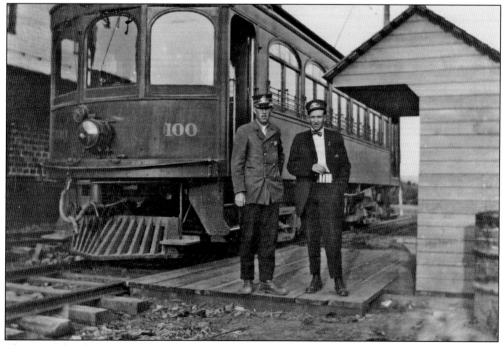

The Henrybro line went due west from Wide Hollow Junction, first to serve a U.S. Bureau of Reclamation project at Harwood, and it was extended in 1913 to Henrybro (also called Gromore). The 100 car and crew are stopped at the Henrybro terminus. The waiting station was typical of the stations YVT used on all interurban lines. One still exists at the YVT powerhouse. (AC.)

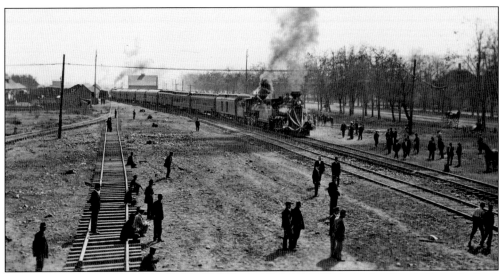

Robert Strahorn, the man behind the UP takeover of the YVT, built the North Coast Railway from the Oregon Railway & Navigation Company on the Columbia River to North Yakima. Both railroads were actually owned by Union Pacific. The first North Coast train to arrive in Yakima is seen here on March 22, 1911. (YVM.)

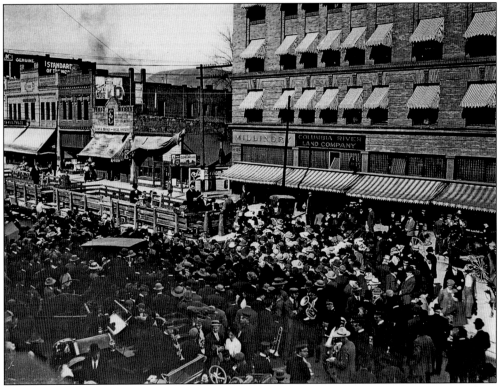

Standing on the back of one of YVT's flatcars, Robert Strahorn addresses the throng in front of the Miller Building on the day the North Coast's first train arrived in Yakima. Brass bands accompanied the event, but Mayor I. H. Schott, who was also supposed to speak, got lost in the crowd. (Union Pacific Railroad [UPRR] Museum, courtesy Hilding Larson.)

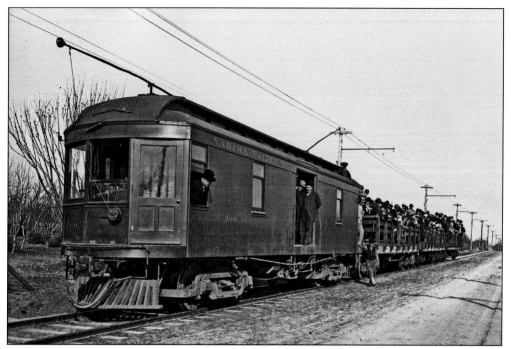

A large group of people had ridden the first North Coast train into Yakima on March 22, 1911, and was treated to a tour of the YVT aboard flatcars with benches. Express motor no. 300 has the train in tow on the Nob Hill line. (UPRR Museum, courtesy Hilding Larson.)

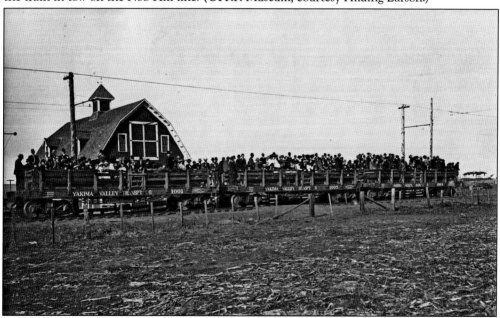

In 1910, YVT ordered 12 flatcars from Seattle Car & Foundry. Some of them were outfitted with benches and railings so that they could haul passengers. Some called them cattle cars, and the name seems to fit in this photograph of a huge crowd of well-wishers packed aboard the cars on the Wiley City line on the occasion of the first North Coast Railway train's arrival in North Yakima. (UPRR Museum, courtesy Hilding Larson.)

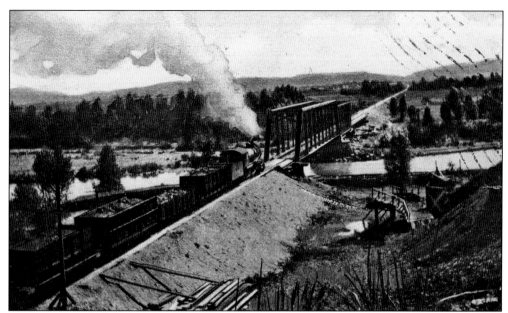

This postcard view shows the Northern Pacific crossing of the Naches River shortly before construction of the YVT line across it (foreground) was started. UP attorney Jeff Asay jokingly named this spot Johnsen's Knoll because of the many photographs the author has taken from it over the years. The view looks south toward Yakima. (YVM.)

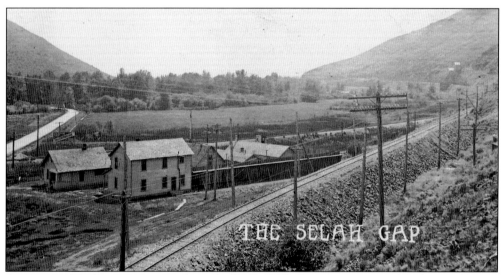

A compound for housing convicts from the Walla Walla Penitentiary separates the YVT tracks (foreground) from the Northern Pacific tracks at the north end of Selah Gap around 1914. A rock crushing plant can be seen in the distance over the YVT tracks. The convicts worked a quarry at the plant from 1911 to 1915. The rock was used in road building. (AC.)

One of two Jewett-built combination cars is seen at Selah in this early photograph. YVT purchased two combination interurbans and an express motor from the company in 1912 for the Selah line. Work on the Selah line began the day after New Year, 1913, and was complete for the first run on June 21 of the same year. Pat Potter was the conductor, and Jack Splawn was an honored guest. (Ron Ott collection.)

A city car is coming in off Fruitvale Boulevard on the left, while one of the Jewett interurbans is heading north to Selah along Sixth Avenue. The Selah line was YVT's last major interurban expansion. (Bob Lowry collection.)

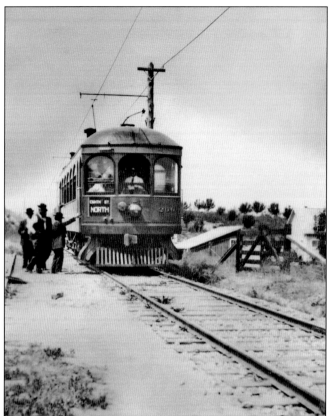

The final section of the Selah line was finished through to Speyers in 1917. Business did not develop as expected on the Speyers portion, and the gain in elevation was too great to make a loop back to Selah as originally intended, so the line was abandoned in 1943. The no. 200 car is seen taking on passengers at Taylor, about a mile short of the terminus. (AC.)

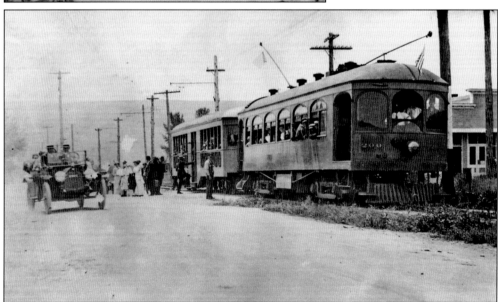

In 1914, YVT purchased four passenger trailer cars from Seattle Car & Foundry. Numbered 50 through 53, they could hold 150 people standing. They were used during fair time and for other special events when the regular cars didn't have enough capacity. One is pictured here with the 200 car in Selah, possibly on a Fourth of July special. (AC.)

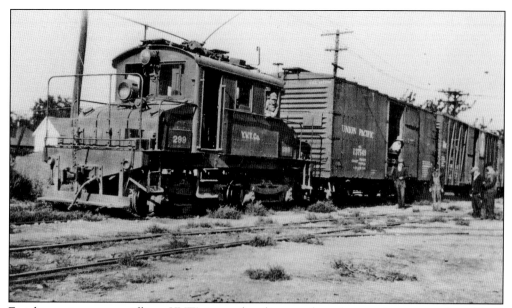

Freight service grew rapidly on YVT's interurban lines, and so a locomotive was purchased from Oregon Electric in 1914 for $7,080. Although it could out-pull the express motors, it did not live up to the hopes of the YVT. As an experiment, five tons of pig iron were attached to each end to try to give it more traction. It did not help. (RSW.)

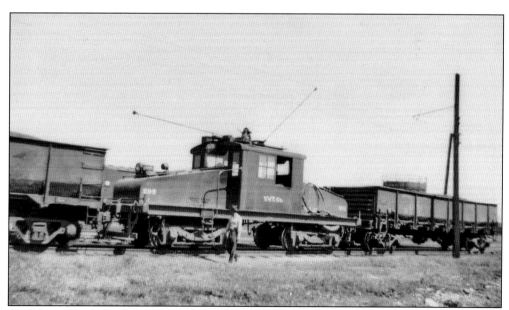

The Union Pacific yards in Yakima shared five interchange tracks with the YVT over which wires were strung. This was YVT's gateway to the world. Steeple cab no. 298 was built in September 1922 and is seen here switching in the interchange yard 26 years later. (AC.)

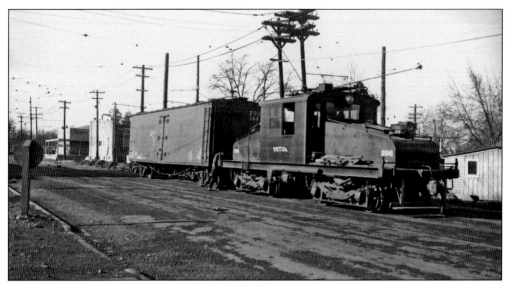

Many refrigerator cars of produce were moved from Yakima packinghouses to the Union Pacific interchange behind YVT steeple cab motor no. 298 from 1922 to 1985. It is shown here on Pine Street in 1947 opposite the carbarn. (Photograph by Harold Hill.)

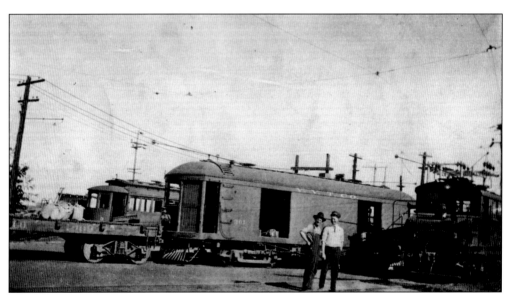

The YVT's own yard, adjacent to its shops, is filled with passenger, work, and freight motors in this 1920 view. Freight motor no. 299 stands at right, single-truck trolley no. 3 is in the background, and motorman Etcyl Floyd (right) and Elmer Evans have just brought in the 301 with a flatcar for track work. (Lawton Gowey collection.)

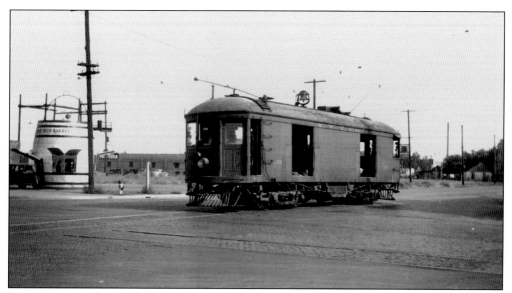

Jewett express motor no. 301, demoted from freight service to track work, clatters across YVT's Yakima Avenue tracks on its way north toward Selah Gap in August 1939. The 301 was geared like a passenger interurban and was never able to pull very many freight cars. (RSW.)

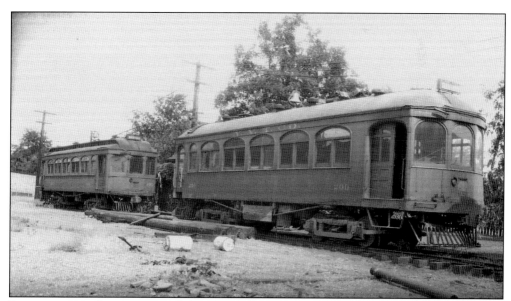

Passenger interurban service ended on YVT on May 15, 1935. The big wooden cars from Niles and Jewett were kept around for a few years and used for storage. Arched-roof Jewett car no. 200 was scrapped in 1939, and clerestory-roofed Niles car no. 100 stayed on YVT property until 1947. (Photograph by Harold Hill.)

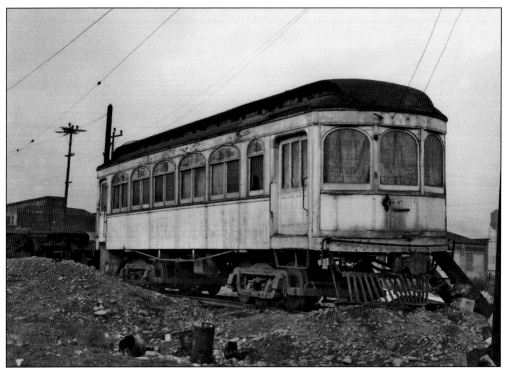

Niles combination car no. 100 was painted white and made ready for work service. Plans to make it a line car fell through, and in 1947, it was sold for scrap. Its body was moved to the east side of town, where it served as tenement housing until it was razed for freeway construction in the 1950s. (Photograph by Lawton Gowey.)

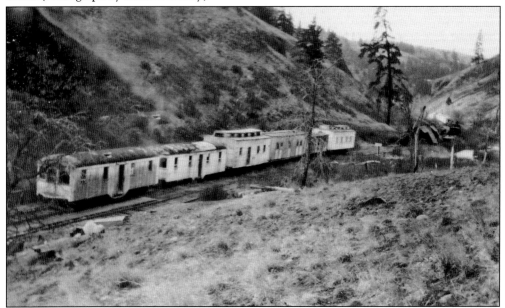

After a few years, the trailer cars were not needed anymore. The dynamics of travel were changing, the state fair got smaller, and YVT was no longer a major player in moving people. Around 1922, the trailers were sold to Cascade Lumber Company at Squawk Creek above Cle Elum. (RSW.)

Three

RISE AND FALL AND RISE AGAIN OF CITY SERVICE

Opinions vary about whether the YVT was intended to be a city transit service or an interurban railroad from the beginning. Newspaper accounts from 1906 and 1907 never mention a word about freight service, and indeed only passenger trolleys were purchased initially. But in letters to the board by early director William Sawyer, there are cryptic references to working out deals with "our friends in the east."

In an interview in 2000, Homer Splawn (Jack Splawn's youngest and last surviving son) told the author that "George Rankin and my Dad had been told from the beginning by the Union Pacific that if they could get a trolley line built from Yakima to the State Fairgrounds, and have two trolleys running on it, the Union Pacific would help them financially."

Whatever their motives, Splawn and company were required by their franchise to provide city passenger service on all lines. This requirement was in effect until the franchise renewal of 1946. At that time, YVT traded its right to operate on Yakima Avenue (for freight from the Cascade Lumber mill on Eighth Street) for permission to abandon all passenger service.

During those 40 years of city transit service, the YVT saw a steady decline in patronage that correlated with a steady increase in the number of automobiles in Yakima. The railroad tried substituting bus service in 1926 and also bought state-of-the-art trolleys in 1930, but by the end of World War II, passenger service was losing too much money.

Following cessation of trolley service (the last in the state of Washington) on February 1, 1947, the YVT provided transit service with a fleet of buses for 10 years. This too was a losing proposition, and at the expiration of its 10-year bus franchise, YVT sold its buses to a private operator and got out of the passenger service for good—almost.

In 1974, passenger trolley service of a tourist nature was revived on the YVT by a consortium of city, county, and private individuals. Today the entire railroad and its trolleys and locomotives belong to the City of Yakima, and the service continues.

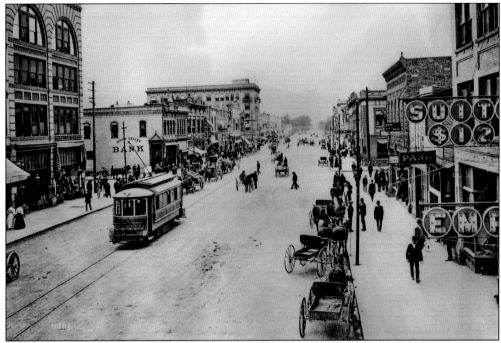

In the horse-and-buggy days, modern streetcars were an amenity usually reserved for larger cities. Yakimans were proud of their up-to-date trolley line, and patronage flourished. This view is of east Yakima Avenue in late 1908, after the track was complete and the new trolleys were placed into service. (Yakima Federal Savings and Loan collection.)

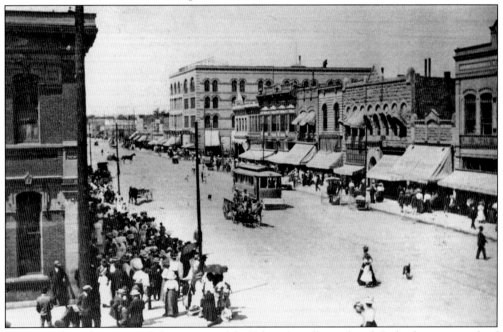

Many people and no automobiles were good for Yakima's trolley railroad. Ridership grew each of the first few years, starting with the initial runs on Christmas Day, 1907, on which 1,320 fares were collected. (KGJ.)

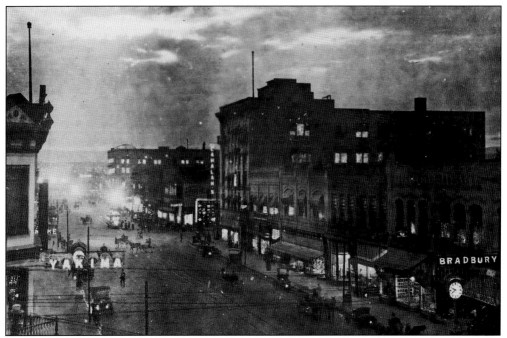

An interesting nighttime view of big-city activity on Yakima Avenue was recorded some time in 1909, before the avenue's second track was laid. Ladies in hoop skirts and their gentlemen are seen climbing aboard one of the single-truck trolleys, perhaps headed off to the theater. (YVM.)

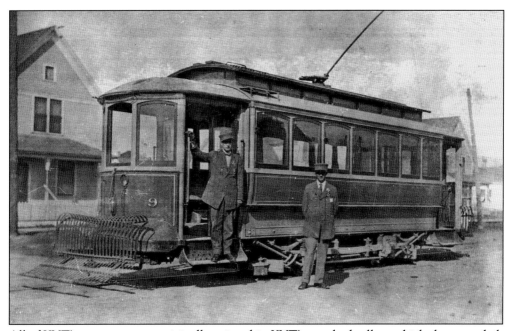

All of YVT's streetcars were originally painted in YVT's standard yellow, which shows up dark on early photographs because of the orthochromatic film used in those days. No. 9 was the last single-truck streetcar purchased by the YVT. (AC.)

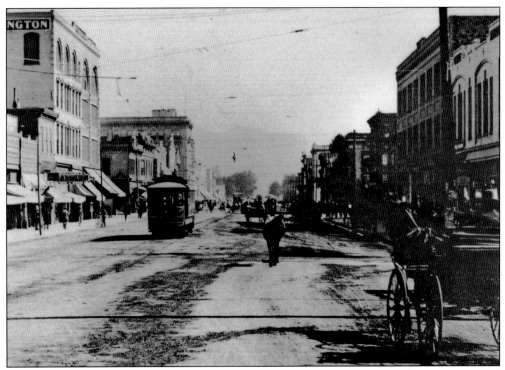

Yakima cars 1, 2, and 3 arrived from the Danville Car Company on September 16, 1908, and were immediately placed into service. One needed slight repairs because a cinder from the steam locomotive pulling the train on which it arrived started a fire on its vestibule roof. (Ron Ott collection.)

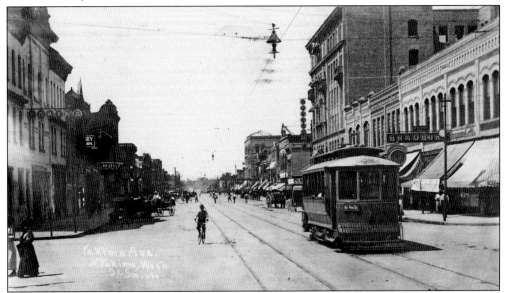

To accommodate the growing business, a second track was laid in Yakima Avenue in 1909. Lines on North Fourth Street and Maple Street were constructed at this time too. The next five pages follow the growth of Yakima Avenue pictorially from a time of horse and buggy to an age solidly dominated by automobiles. (YVM.)

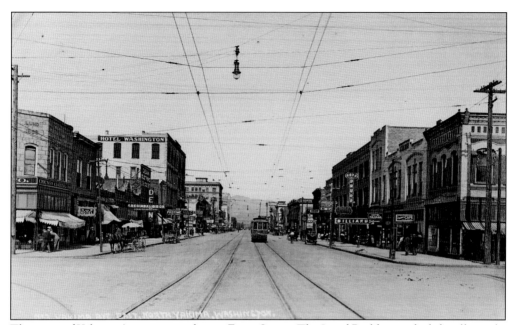

This view of Yakima Avenue was taken at Front Street. The Lund Building at far left still stands. Not many of the other buildings in this 1910-era photograph are still standing. At this date, YVT was still carrying several thousand riders a day. (YVM.)

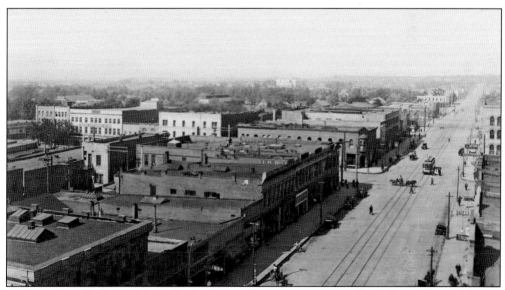

In this view of Yakima Avenue looking west from an upstairs perch in the Miller Building, a lone automobile, a sign of things to come, can be seen approaching. Yet 1911 was a record year, averaging 5,222 riders per day. (YVM.)

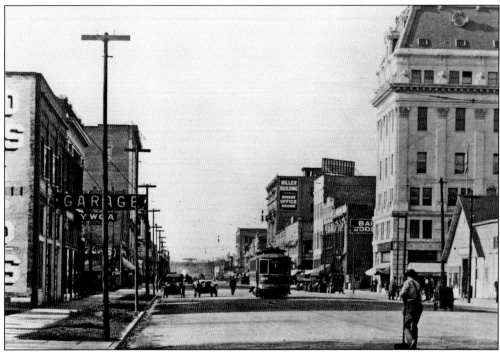

As the teens dawned, automobiles suddenly started showing up in greater numbers. The employment future indeed is not too bright for the man in the upper photograph shoveling horse manure off Yakima Avenue. The age of horse and buggy would quickly vanish, and with it would go many YVT passengers who now reveled in the comfort and convenience of the private automobile. The imposing building to the right is the Masonic temple, which was built during the time of YVT's first track laying. It still stands today, one of the last tangible reminders of early North Yakima. (Both, Ron Ott collection.)

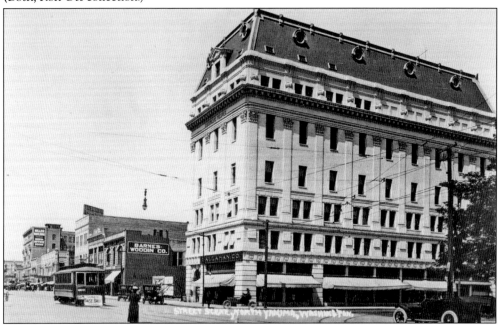

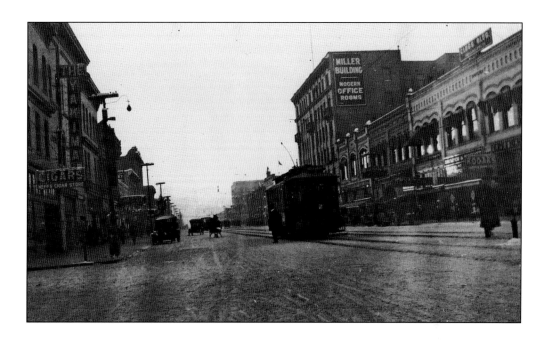

The two views on this page, taken in the heart of downtown Yakima during the teens, look each direction on Yakima Avenue. The upper view shows a wintertime picture at about Third Street. Note there is still a horse-drawn sleigh among all the automobiles. The lower view clearly shows the Courthouse Loop track coming off the Yakima Avenue main line at Second Street. In 1916, YVT began repainting its trolleys dark, solid Pullman green instead of the ornate yellow scheme originally used. (Both, YVM.)

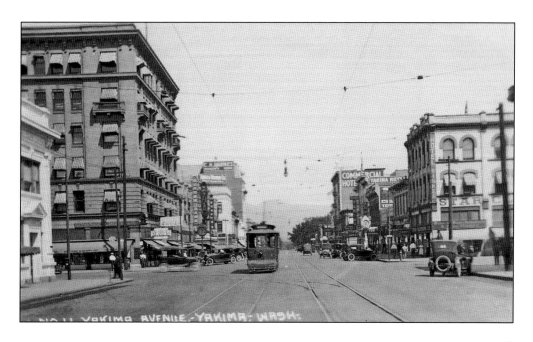

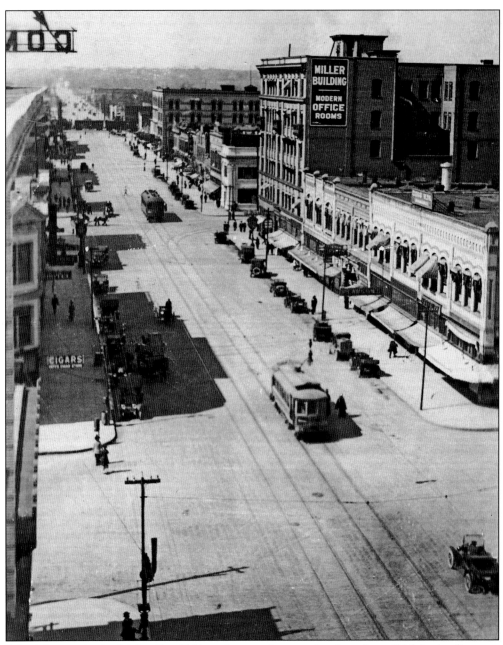

A lot is happening in this bustling Yakima Avenue photograph taken about 1914. In the distance, a Northern Pacific switch engine is shuffling cars across the avenue. A little closer, one of the Jewett interurbans has just picked up passengers for the trip to Selah. And in the foreground, a westbound single-truck city car is discharging some passengers. (YVM.)

On June 19, 1916, YVT placed one-man cars in operation in order to cut the crew size in half and save money. The difference in configuration of the cars' vestibules is seen in these photographs. The vestibules were arranged more like a modern-day bus. The car in the upper photograph is running as a "jigger car," one that makes a run from Front Street to South Nob Hill Boulevard between the runs of regular full-line cars during peak hours. The dapper motorman (Pat Potter, above left) and conductor (unidentified) are posing with their conveyance at the west end of the line in 1914. (Above, Ron Ott collection; below, YVM.)

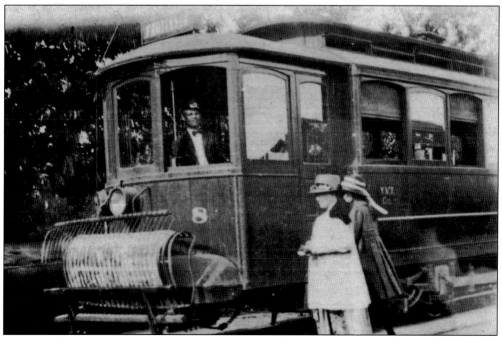

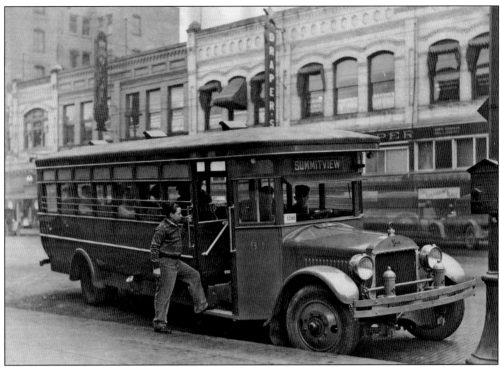

Private automobiles and jitneys were eating into YVT business. To stem the downturn in patronage, YVT decided in 1926 to try substituting a bus for the aging single-truck streetcar on the Summitview line. Mack 29-passenger bus no. B-1 was purchased and became an immediate hit with passengers. The company then tried buses on several other lines but did not meet with the same success, and so the streetcars returned. (AC.)

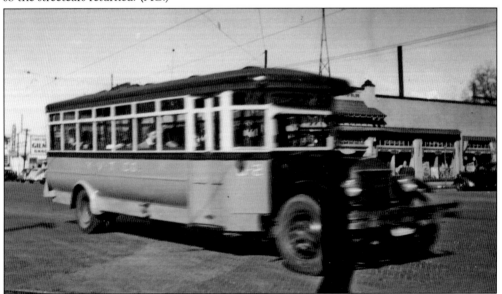

Ultimately, YVT purchased three Mack buses, B-1, B-2, and B-3. No. B-2, painted and lettered in the same scheme used by the Master Unit streetcars, is seen in the 1940s speeding along Yakima Avenue. (RSW.)

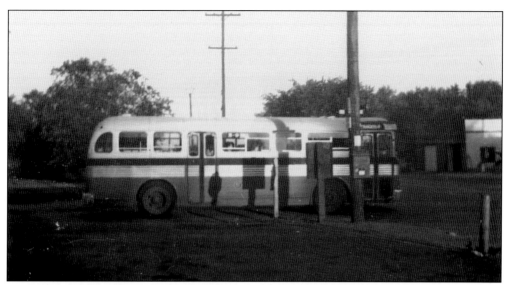

YVT was a loyal customer to Twin Coach from no. B-4 on, ultimately owning 18 of their buses. Painted green, gray, and ivory, the buses began arriving in 1940 and lasted into the late 1950s. Here B-9 is turning right onto the Fairview line. (AC.)

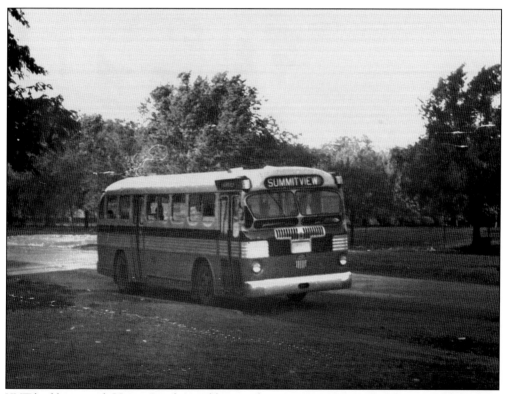

YVT had buses with Union Pacific's emblem on them, owing to Union Pacific's ownership of the line. The Twin Coaches also had a small circular YVT emblem on the lower side, just ahead of the rear door. The modern bus is seen here passing the state fairgrounds on its way to Summitview Avenue. (RSW.)

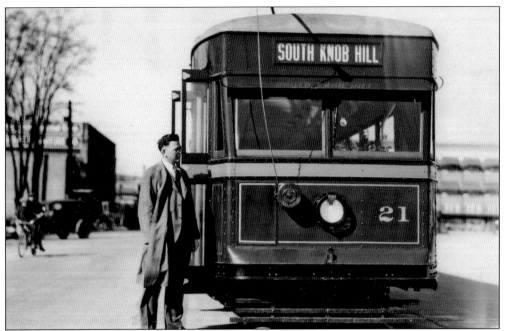

Because of the flexibility of buses, YVT had asked the city to allow it to replace all streetcars with buses in 1926 and again in 1929, but both times the city maintained that streetcar service was mandated by the 1906 franchise. In a last desperate attempt to woo back passengers, YVT purchased three new Brill Master Unit streetcars in 1930, nos. 20, 21, and 22. These cars were the newest cutting-edge technology in 1930, and the railroad was justly proud of them. In the upper photograph, YVT superintendant Walter S. Howard poses with no. 21 on March 8, 1930. Below, Yakima mayor W. W. Stratton hands a Washington State apple to Bess Campbell, a stenographer from the Oregon Railway & Navigation Company (OR&N) who posed as the "first passenger." (Both, AC.)

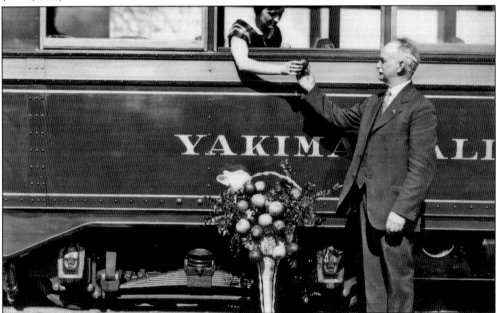

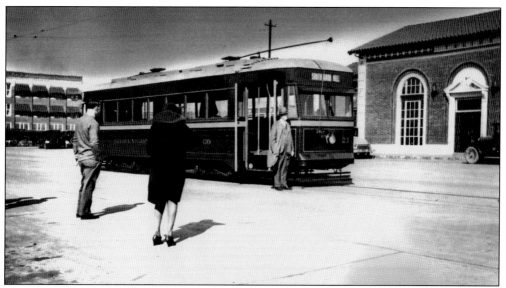

On Saturday, March 8, 1930, one of the new Brill Master Units was placed on display for public inspection on Second Avenue in front of the OR&N depot. The contrast between this modern car, with its electric heating, leather seats, and low-slung body, and the old, cold, rickety wooden cars with their cane rattan benches, was very obvious. (RSW.)

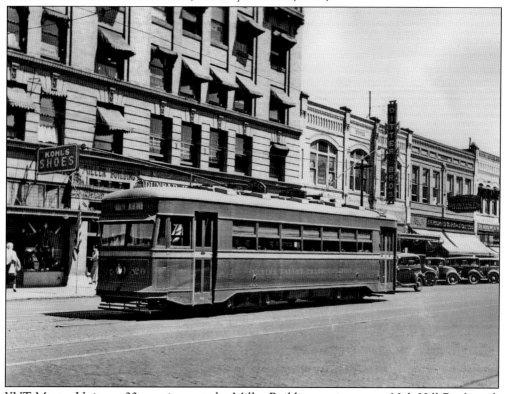

YVT Master Unit no. 20 scurries past the Miller Building on its way to Nob Hill Boulevard. Shades are pulled on this sunny day, and the no. 20 is still dressed in its original livery of dark green, with a stripe of light green bordered in blue. (Lawton Gowey collection.)

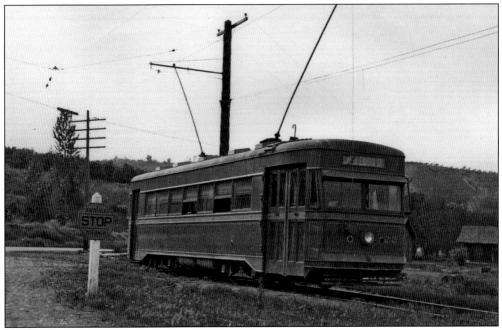

At the west end of the Fruitvale line, Master Unit no. 22 is having its poles reversed for the trip back to North Eighth Street via the OR&N depot in town. Ridership went up with the new Brills, and the railroad received letters and compliments from riders. Today this point is at Powerhouse and Castlevale Roads due to changing roadway alignments on Fruitvale Boulevard. (AC.)

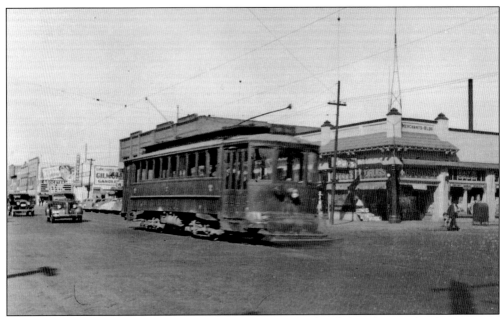

With the advent of the Master Units, passengers showed a decided preference for the new cars, and so the older cars were put on the less used routes. No. 7 in its Pullman green paint, rattling along Yakima Avenue, was not what the car riders wanted to see picking them up. (RSW.)

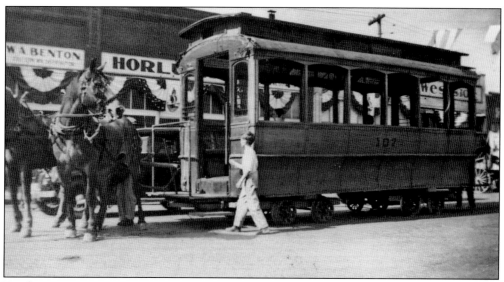

Yes, horse cars ran on YVT—just once. From May 17 through May 19, 1935, a horse car was operated for the Frontier Days celebration. It was created from the body of Seattle Muni streetcar no. 107, still in Seattle orange colors. Its conductor was Ed Sanders, a former YVT interurban motorman. (RSW.)

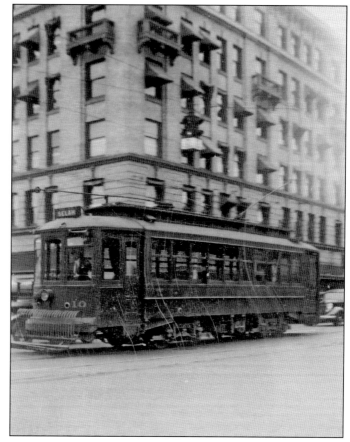

The only second-hand streetcars YVT ever bought were no. 10 and 11, purchased from the Yonkers Street Railway Company in April 1914. Built by Stephenson in 1904, these Brill semi-convertible types were older than any other YVT streetcars, but they lasted in service until 1939, long after the single-truck cars had all been scrapped. The Hunter Illuminated Car Signs were installed on YVT streetcars in 1917. (RSW.)

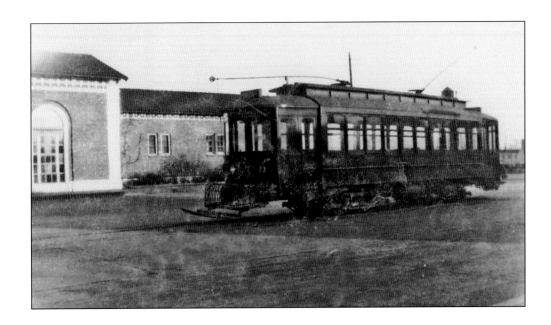

The two Yonkers cars were like stepchildren, never appreciated as much by YVT motormen. In the photograph above, no. 11 stands on Second Avenue in front of the Union Pacific (OR&N) depot. This depot was one of Yakima's portals to the world. People from everywhere would arrive on a Union Pacific train at this terminal and board a Yakima trolley for downtown Yakima. Notables such as John Phillip Souza and evangelist Billy Sunday did just that. The building still stands today, used by Yakima schools for office space. (Both, RSW.)

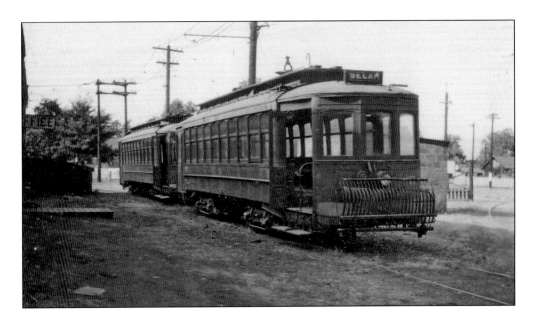

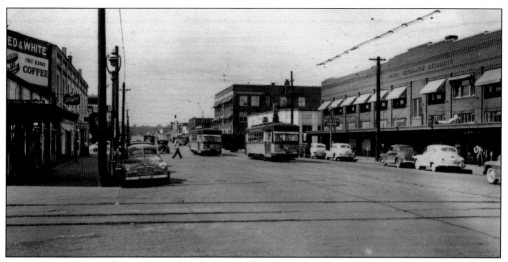

Master Units 20 and 21 pass each other on Yakima Avenue just west of the Northern Pacific crossing. This section was part of the original 3 miles of the YVT, originally built as single track and later double-tracked. To cut costs, the portion of the Yakima Avenue line crossing the various tracks of the NP remained a single track. (AC.)

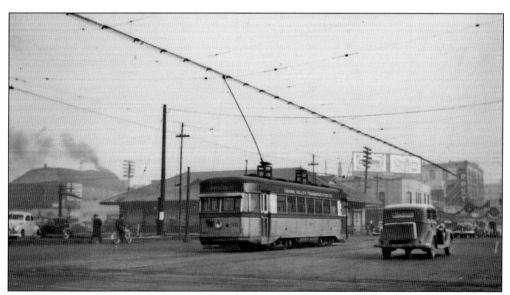

YVT's wire over the Northern Pacific crossing was suspended higher than elsewhere to accommodate the steam road's trains. It also had an outer wire on each side so that if the trolley became dewired, it could still get power and avoid colliding with a steam train. Consequently, the poles on the low-slung Master Units were longer and their bases raised up on a platform. This photograph was taken on the last day of 1946. (RSW.)

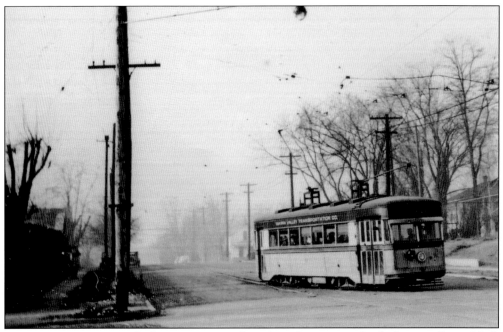

Master Unit no. 21 rounds the corner going from Pine Street onto Sixth Avenue. Davis High School is now located at this spot. The Master Units received their new green, gray, and cream paint scheme in 1935 (AC.)

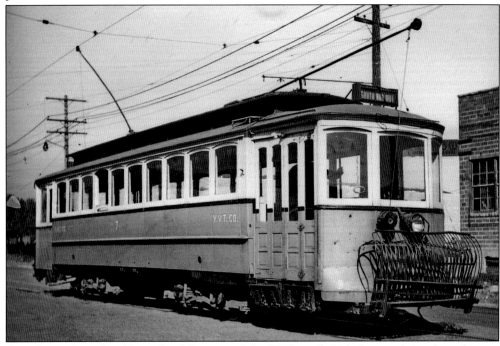

Complaints about the old cars 6 and 7 prompted the YVT to refurbish them and give them the new color scheme of the Master Units. No. 6 emerged from the shops in 1940 and had its longitudinal benches replaced with transverse seats cannibalized from the interurban cars. No. 7 came out sporting the new scheme in 1942 but still with its longitudinal benches. (Photograph by Ed Maas.)

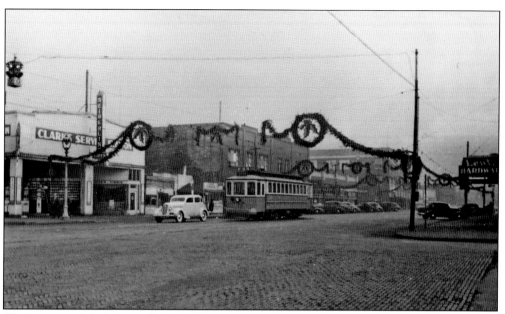

Christmastime's holiday rush finds YVT no. 6 heading westbound on Yakima Avenue at the crossing of Third Avenue. (RSW.)

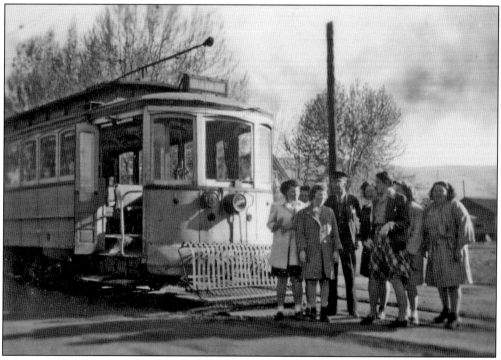

A group of ladies visiting Yakima and touring by streetcar persuaded the motorman to stop car no. 6 and get out and be photographed with them. Coal smoke and smudge-pot smoke often filled the air above Yakima. (AC.)

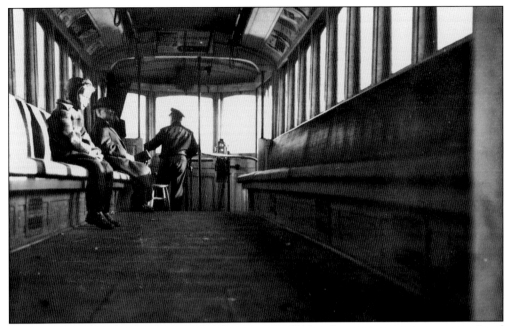

Although built by John Stephenson Car Company in 1910 with transverse seats, cars no. 6 and 7 were converted to longitudinal benches in 1918. No. 6 got the more comfortable transverse seats reinstalled in 1940, but no. 7 kept the benches to the end. Harold Hill's son rides the no. 7 on January 18, 1947. (Photograph by Harold Hill.)

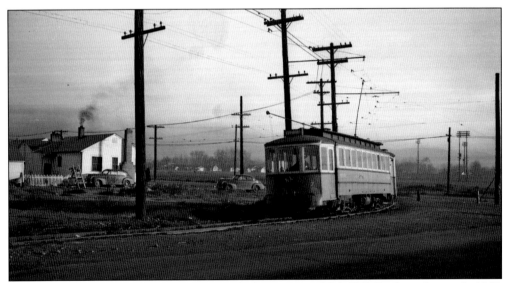

YVT no. 7 rounds the corner from Sixteenth Avenue onto Nob Hill Boulevard in early 1947. Today this curve still exists in the roadway as a turning lane in the intersection of two busy five-lane roads. (Photograph by Harold Hill.)

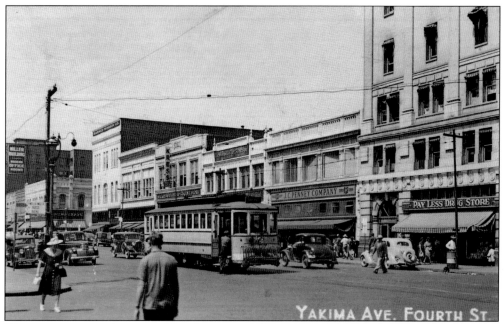

This wartime view shows no. 6 heading east on Yakima Avenue past the Masonic temple. In 1942, to help with metals drives, YVT removed abandoned tracks from Summitview Avenue, B Street Loop, Eleventh Avenue, Twelfth Avenue, Fourth Street, and Yakima Avenue from Sixth Avenue to Twelfth Avenue. (YVM.)

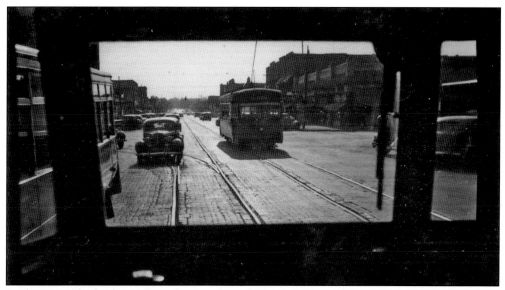

Looking out the back window of an eastbound Master Unit at the crossing of Second Avenue and Yakima Avenue, one of the Mack buses can been seen on the left, and westbound Master Unit no. 21 is disappearing from view in the center. (AC.)

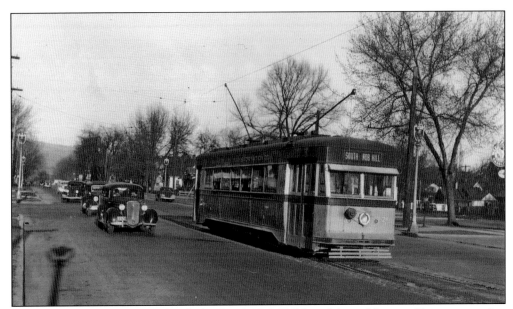

The Fairview line was coupled with the South Nob Hill line. Master Unit no. 21 is seen coming back into town along Sixth Street on the east side of town. (Robert Lowry collection.)

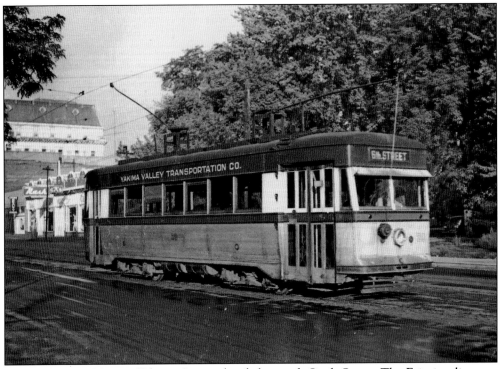

Master Unit no. 20 is on Yakima Avenue headed towards Sixth Street. The Fairview line was torn up in 1938, five years after Yakima's fair stopped being the state fair. (AC.)

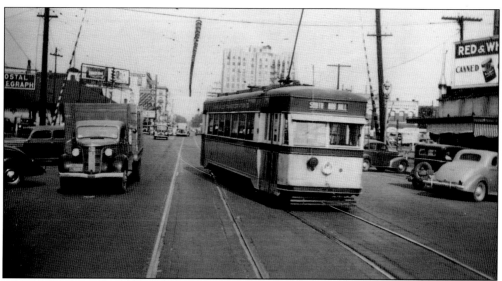

Master Unit no. 21 is eastbound on Yakima Avenue approaching the Northern Pacific crossing. Here the double track narrows down to single track so that only one track crosses the steam railroad. Besides the obvious dollar economy of this configuration, it is a safety feature too. Special catenary wiring is suspended above the crossing. In case of dewirement, the trolley wheel will find an adjacent wire and still be able to make it across. (AC.)

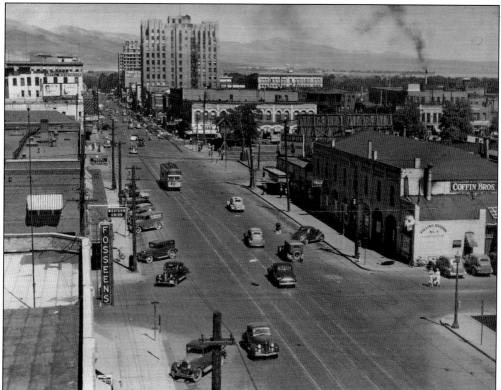

This aerial photograph gives a bird's-eye view of the same location seen in the upper photograph. (YVM.)

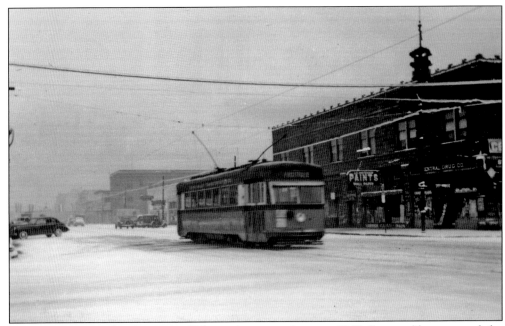

Master Unit no. 21 heads west on Yakima Avenue in January 1940. Snow seldom stopped the YVT, even though it is on the ground sometimes five months out of the year. In the early days, YVT no. A was outfitted with a wooden snow scraper and wings to clear the track, but this was found to be unnecessary. (RSW.)

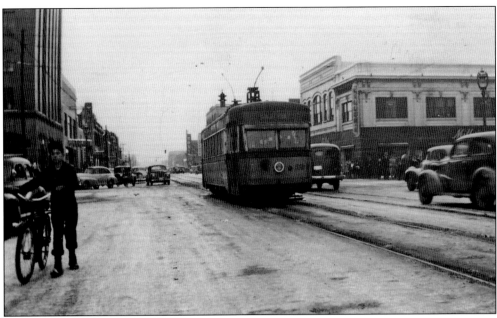

Motorman Adam Siegmeth photographed his trolleys in their last winter of operation. YVT no. 20 is eastbound on Yakima Avenue in early 1947. (Photograph by Adam Siegmeth.)

Fellow motorman Joe Mullens posed in his Master Unit for Adam Siegmeth in the last month of trolley operation on the YVT. (Photograph by Adam Siegmeth.)

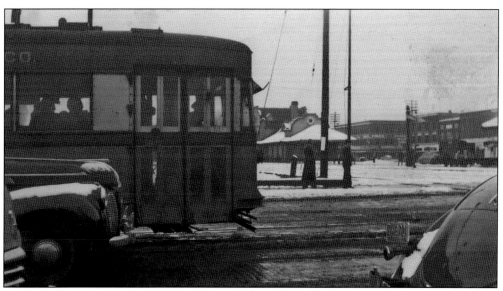

A Master Unit mixes it up with heavy automobile traffic eastbound on Yakima Avenue near the Northern Pacific depot in January 1947. (Photograph by Adam Siegmeth.)

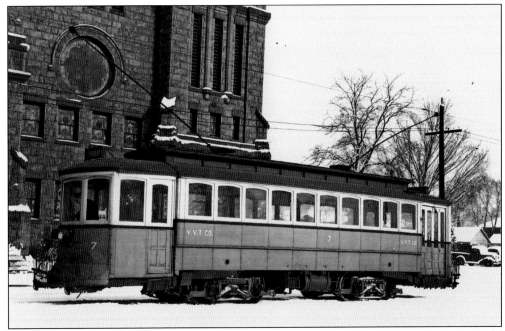

YVT no. 7 is seen on its last day of service, February 1, 1947. On that fateful evening, it would lead the final parade of streetcars down Yakima Avenue. Sister car no. 6 broke an axle and was not able to participate. (Photograph by Al Farrow.)

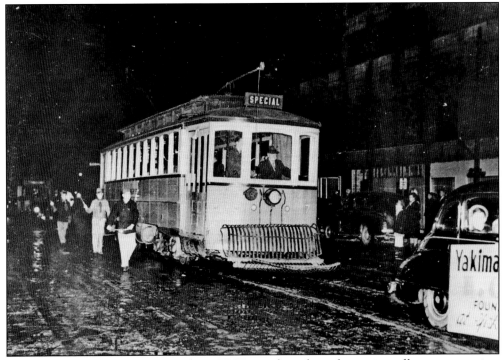

By giving up its Yakima Avenue trackage, YVT won the right to discontinue all streetcar service, and a ceremonial final parade was staged on February 1, 1947. No. 7 led the parade. On board were Mrs. Nick Richards and the Davis High School Band. Athol Chapman was motorman. (AC.)

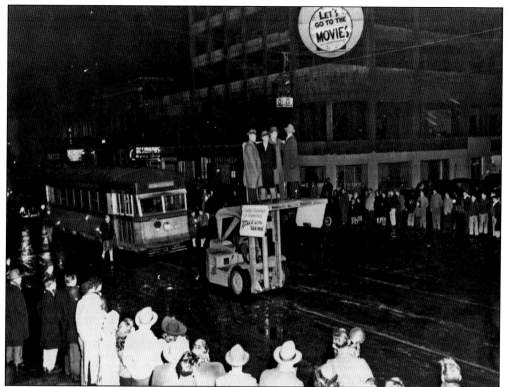

Yakima Junior Chamber of Commerce officials ride a Hyster to cheer the cessation of streetcar service and the institution of buses during the "Parade of Progress." The date is February 1, 1947, and all available streetcars are involved. After the parade, regular runs continued until midnight, and the final car was motored by J. Wallace Estes, who had run the final interurban car years earlier. (AC.)

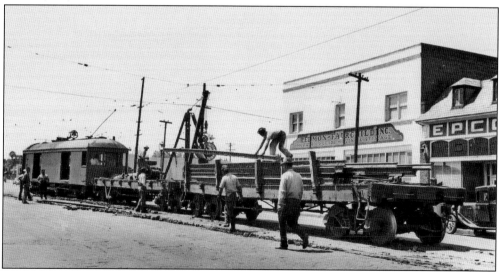

In June 1947, express motor no. 301 has the dubious honor of being the last YVT electric motor to operate on Yakima Avenue. YVT's lines east were removed that summer, and the railroad settled into its new role as a freight-only carrier. (Photograph by Al Farrow.)

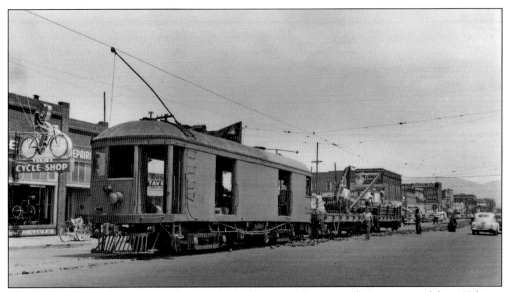

Thirty-nine years after these tracks were laid, all traces of them are being removed from Yakima Avenue following the franchise renewal that specified no tracks in Yakima Avenue. The YVT lost lucrative Cascade Mill as a customer in this deal but won the right to end streetcar service. This photograph was taken on June 12, 1947. (Photograph by Al Farrow.)

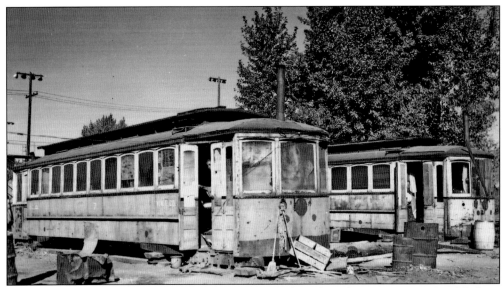

Following the end of streetcar service, YVT sold the bodies of Stephenson cars no. 6 and 7 along with Niles interurban no. 100 to Valley Junk Company. They were moved to a southeast location and used as tenement housing until some time in the 1950s, when they were razed to clear the land for a new freeway. (Photograph by Bruce Holcomb; courtesy RSW.)

The growl of bus motors has replaced the singing of the trolley wire on Yakima Avenue in this 1949 view. YVT ran the bus system until its franchise expired in 1957. At that time, all its buses were sold to D. S. Peck, who owned Yakima City Bus Lines and ultimately went broke. From 1966 to 1970, an interim company ran the buses. The City of Yakima finally took over bus operations in 1970. (AC.)

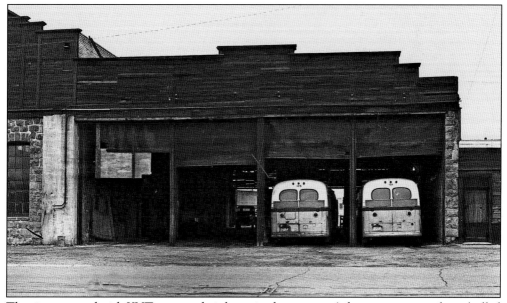

The city arranged with YVT to store their buses in the company's former car storage barn (called the running barn by YVT). The running barn was demolished by YVT in August 1976, and by that time the city had arranged for offsite storage of its buses. (Photograph by Hilding Larson.)

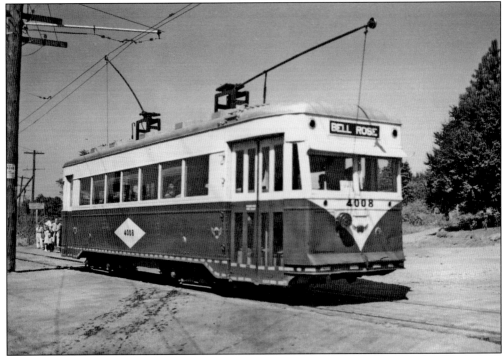

Master Unit no. 20 was retired in 1947 and sold to Portland Traction Company the following year, where it became their no. 4008. It had another decade of service in the Rose City before finally retiring to the railroad museum at Snoqualmie, Washington. (Photograph by Charles Savage.)

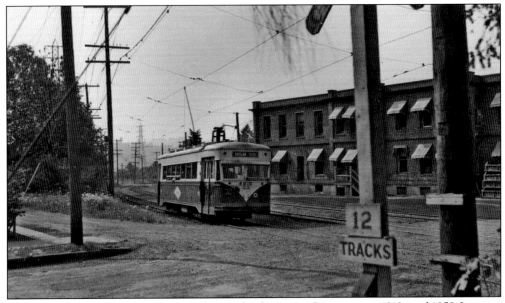

Former YVT Master Unit no. 22 operated as Portland Traction Company no. 4010 until 1958. It is seen here hurrying to Oregon City near the end of its second career. (James Harrison collection.)

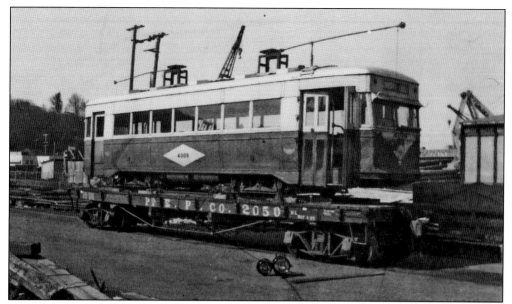

Snoqualmie-bound former YVT Brill Master Unit no. 21 has finished its second career at Portland Traction and is heading back to Washington. Purchased by meat-cutter Bob Hively along with Master Unit no. 22, the sleek Brill will face an uncertain fate at Hively's steam locomotive–dominated museum. (AC.)

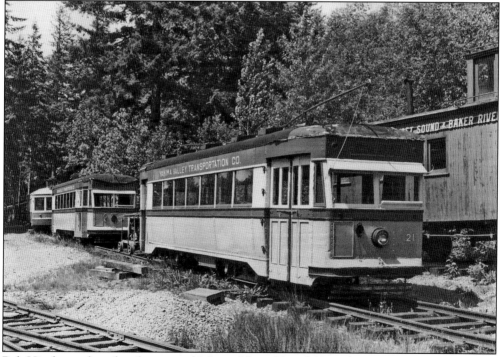

Bob Hively purchased and repainted Master Units 21 and 22 in their YVT paint scheme and ran one of them at the railroad museum at Snoqualmie, Washington, for a while. A homebuilt motor-generator car provided the power. Eventually Hively sought a new home for his cars as the museum's emphasis shifted more to steam. (KGJ.)

In 1973, Yakima City councilman Wray Brown took the author's proposal for renewed trolley service and turned it into reality. He was a successful grocer, part-time photographer, and politician, and his connections in high places facilitated bringing trolleys back to Yakima. He retired from the trolley operation in 1984. (KGJ.)

The search for trolleys to reopen service in Yakima went worldwide. Broker Paul Class found two trolleys in Oporto, Portugal, identical to this one that were still in operation. Armed with money and letters of introduction, Class purchased cars no. 254 and 260 and helped refurbish them. (Photograph by Paul Class.)

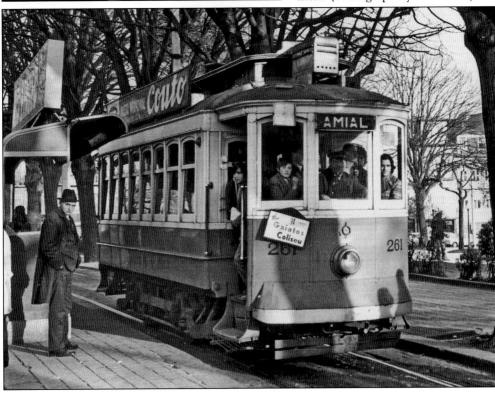

Sonja Class helped her husband, Paul, work on the refurbishment of Yakima's trolleys alongside the Portuguese craftsmen at Oporto. The cars were refreshed from the ground up. The red-and-cream paint scheme for them was selected by Wray Brown after he saw a similar scheme on photographs of tramcars in Lisbon. (Photograph by Paul Class.)

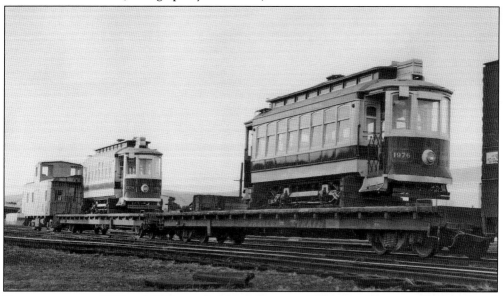

Oporto streetcars 1976 and 1776 traveled from the port of Houston, Texas, to Yakima aboard flatcars always spotted just ahead of the caboose. A special agent of the railroad rode with the trolleys the entire distance to protect them from vandalism. They arrived in town during the pre-dawn hours of August 28, 1974. (KGJ.)

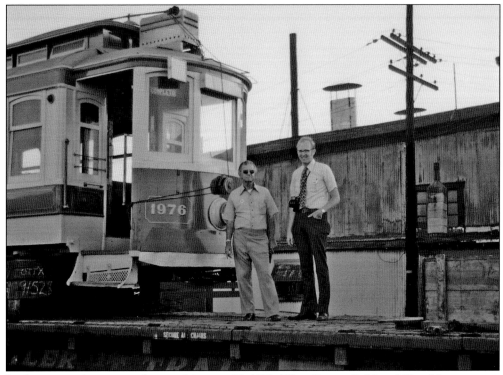

In the very early morning hours of August 28, 1974, Wray Brown (left) and Ken Johnsen went down to Yakima's Union Pacific yards to greet what they had worked so hard for. The two beautiful trolleys from Oporto greatly surpassed their expectations. (Photograph by Rosella Brown.)

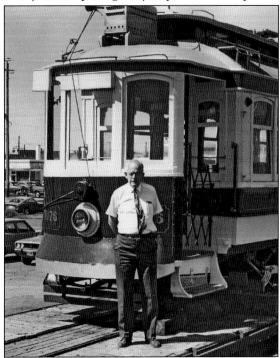

Robert S. Wilson was born in Yakima in 1912. As a small boy, he became fascinated with the YVT, and during his school years, he took meticulous notes about anything happening on the railroad. He was a gentle and unassuming person, and posterity is indebted to him for preserving so much of YVT's lore. Here he greeted the Oporto trolleys when they arrived in town on August 28, 1974. (KGJ.)

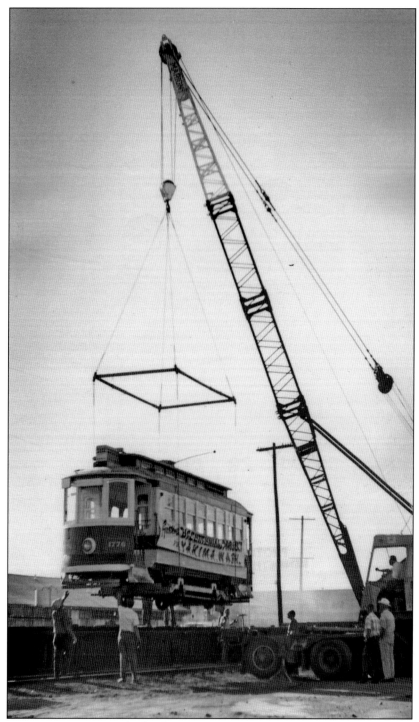

The date is August 29, 1974, and it has been 44 and a half years since a new trolley was unloaded in Yakima. Former Oporto trolley no. 1776 was lifted off its flatcar and set on the Union Pacific team track. YVT's high-rail truck pulled it over to YVT tracks, where its trolley pole could be lifted to the wire. (KGJ.)

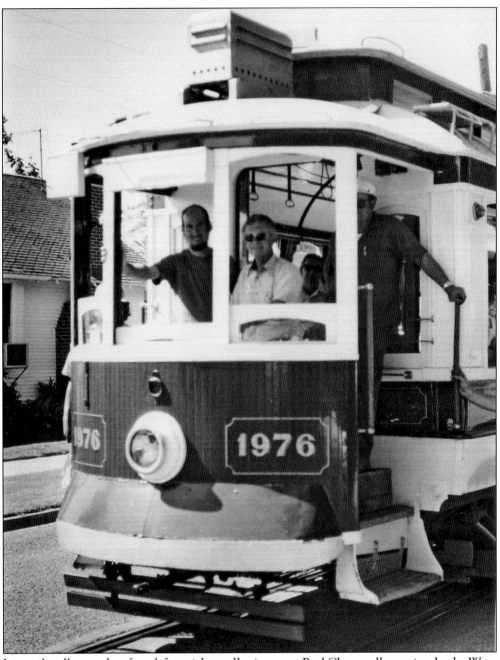

It is smiles all around as, from left to right, trolley importer Paul Class, trolley project leader Wray Brown, and YVT manager Jerry Price, along with invited guests, enjoy the very first trip of an Oporto streetcar in Yakima on August 29, 1974. (KGJ.)

Wray Brown applied his energy and his financial resources to make the modern trolley program a success on YVT. Professional motormen, dressed in snappy, vintage uniforms, were part of that drive. Wray purchased these hats and badges and made them standard attire for all motormen. Motormen at this time were actually employees of the City of Yakima. (KGJ.)

Ben Alaimo was appointed by Wray Brown as trolley master for the two Oporto cars. Ben, along with most of the other initial motormen, was an off-duty fireman. His clever wit and humorous antics made him a hit with passengers whenever he motored the trolleys. (AC.)

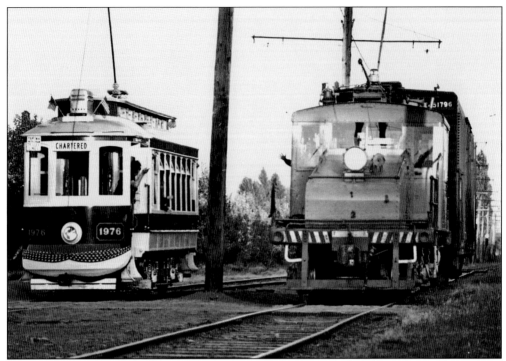

Yakima's new trolleys shared the YVT railroad with the freight trains. Freight trains had right of way. Freight motorman Mel Lucas waves to the riders in the hole at Congdon's orchards. (KGJ.)

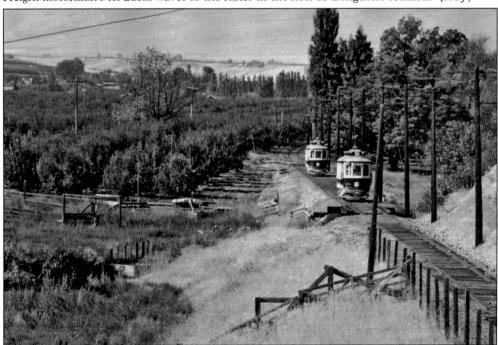

The first public runs of the Oporto trolleys were held on Columbus Day, 1974. Both cars were filled to capacity on every trip and ran in tandem from Whitney School to Congdon's Castle. Yakimans embraced the return of trolleys to their city with great enthusiasm. (KGJ.)

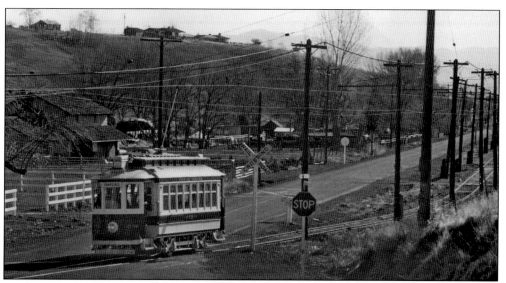

In the spring of 1975, Oporto car no. 1776 makes one of its first revenue trips to Henrybro. A couple from the east and their infant child have chartered the car for the day and are out to ride on all 21 miles of in-service track. (KGJ.)

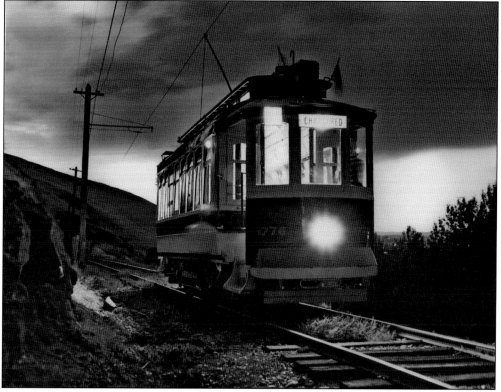

The renewal of passenger service on the YVT included nighttime runs to Selah and back. The line through Selah Gap follows the Yakima River along a narrow shelf on the canyon wall. The 32-seat Oporto car pauses here in August 1975 to let passengers have a close look at the river below. (KGJ.)

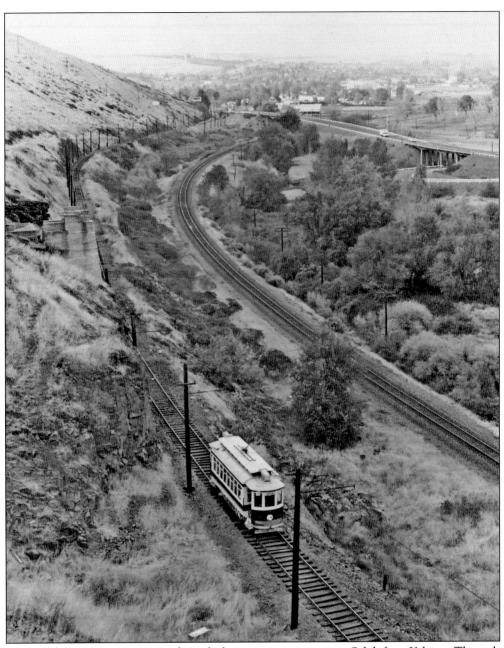

Scenic Selah Gap is a narrow cut through the mountains separating Selah from Yakima. Through it pass the YVT, the Northern Pacific (BNSF), the highway, and the Yakima River. The concrete foundation at left is all that remains of a rock-crushing plant that operated here from 1911 to 1915. (KGJ.)

Four

FROM FREIGHT ONLY TO A LIVING MUSEUM

The new franchise YVT obtained from the city in 1946 lopped off the railroad's east side but set it free of having to provide passenger trolley service. The franchise term was reduced to 25 years. Now the railroad could do what it always wanted to: haul freight to the Union Pacific interchange.

Yakima Valley likes to bill itself as the "Fruit Bowl of the Nation," and it does produce an amazing amount of apples, pears, cherries, apricots, and other fruit. It is no surprise that YVT's main commodity was perishable fruit, hauled from the many packinghouses along its line in refrigerated cars. But a large door and plywood factory on North Sixth Avenue provided the railroad's second-highest volume of freight cars. Coal yards and petroleum facilities also generated business.

When the second franchise expired in 1971, there arose a Safe Streets Committee whose goal was to get YVT off of the city streets. There had been some fatal auto/train accidents (not the fault of the railroad), and emotions ran high. City council deliberations ran on for over a year, during which time the railroad had no franchise and operated on a temporary extension permit. Finally, in 1973, the Interstate Commerce Commission (ICC) stepped in and told the city that YVT was a common carrier, and the city did not have the power to stop its operations. A new 10-year franchise was granted that put restrictions on hours of operation.

Whether the restrictions killed the business or the railroad just got tired, it applied for abandonment in 1984. ICC permission was granted, and the railroad made its ceremonial final run on November 18, 1985. Owner Union Pacific donated the track, power distribution system, two locomotives, two flatcars, a tank car, and contents of the carbarn and powerhouse to the City of Yakima so that the Oporto trolleys could continue running. The carbarn property at Third Avenue and Pine Street was retained by UP but later sold to a mental health organization that in turn sold it to the City of Yakima.

So the collection is complete, and the historic YVT railroad has become a living museum of early-20th-century interurban electric railroading.

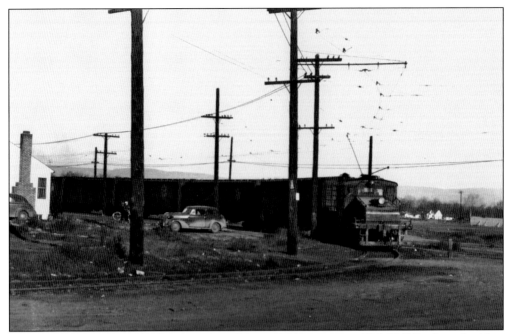

Steeple cab no. 298 rounds the curve from Sixteenth Avenue onto Nob Hill Boulevard with a train of Pacific Fruit Express (PFE) refrigerator cars in tow. In 1948, YVT considered a proposal from Cummins Diesel to rebuild the 298 and 297 into diesel-electric locomotives. The change was considered too costly for the minor benefit gained (elimination of overhead wire maintenance). (Bob Hively collection.)

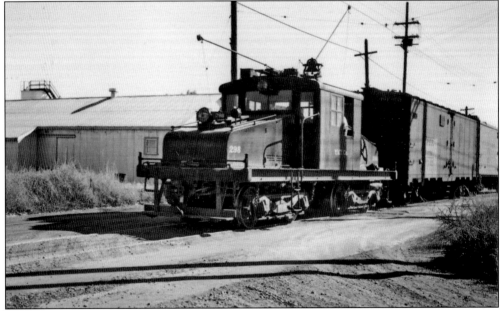

YVT motor 298 crosses the Northern Pacific Naches Branch track on North Sixth Avenue in 1948. This scene remains the same today, right down to the descendants of the tumbleweeds that still blow around in the fall. This is the only remaining YVT crossing of another railroad today. (Bruce Holcomb photograph, courtesy RSW.)

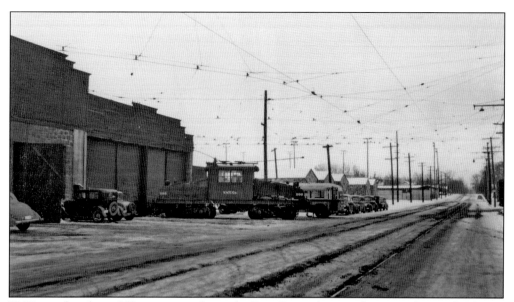

YVT steeple cab no. 298 prepares to leave the Pine Street shops and running barn. The 50-ton weight of the locomotive enables it to crush through the snow and ice visible on the tracks in this wintertime photograph. (RSW.)

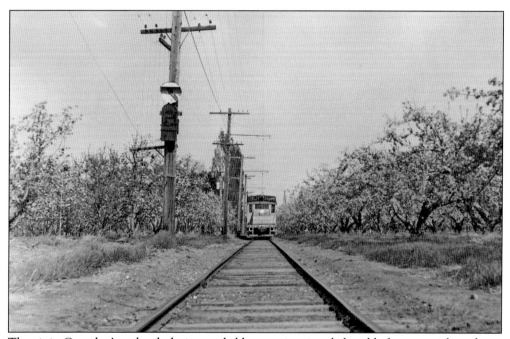

The air in Congdon's orchards during apple blossom time is unbelievably fragrant with perfume. Wiley City–bound 298 is about to pass one of YVT's Chapman semaphore block signals. The position of the semaphore indicates no train in the block occupied by 298. Thus one must assume the signal was nonfunctional at this time. (KGJ.)

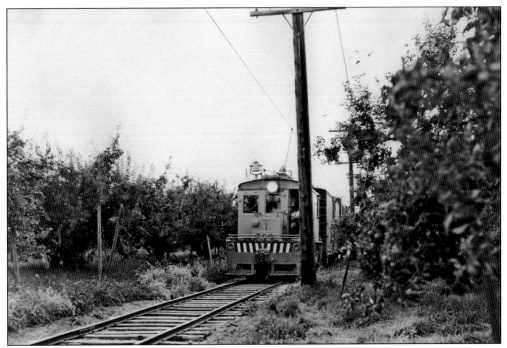

At harvest time in September, the apple trees in the Yakima Valley become so heavily laden with fruit that the branches must be propped up with boards to prevent breakage. YVT no. 297 brings a cut of refrigerator cars back to town through Congdon's orchards. (KGJ.)

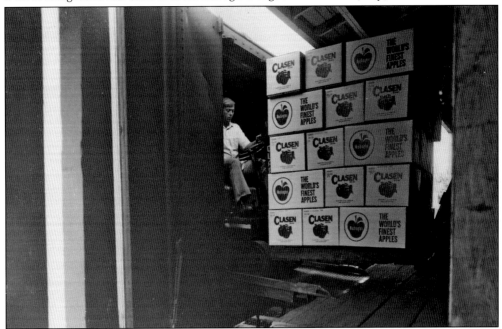

YVT has been called the "Apple Country Interurban," with good reason. Its three extensions into the farm country were used to annually tap many carloads of produce, primarily apples. Walt Shoot and his crew wait patiently in the cab while the last boxes of red delicious apples are loaded into a PFE reefer bound for New York. (KGJ.)

Conductor Walt Shoot tends to "business" at his desk in the cab of 298 while he and the crew wait at a packinghouse for the warehousemen to finish loading a car for shipment. Personalized service like this won YVT many loyal customers. Shoot began working for YVT in 1944. (Photograph by Ted Benson.)

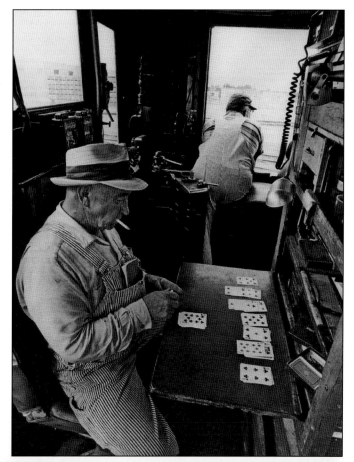

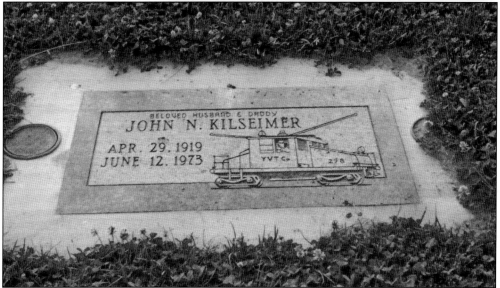

This image of YVT 298, from a drawing by the author, adorns the grave of YVT motorman John Kilseimer at Tahoma Cemetery in Yakima. (Photograph by John Ainsworth.)

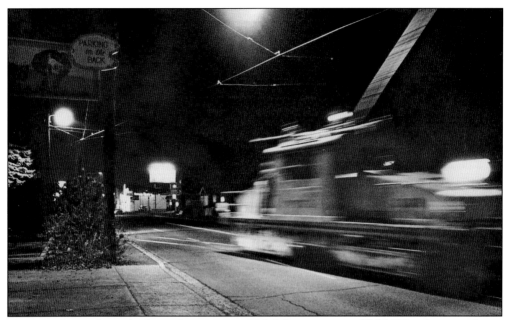

Trains work into the night during harvest time, YVT's busiest season. YVT 298 and its crew hurry back into town with one last reefer from Wiley City in October 1981. They are eager to drop off the reefer in UP's interchange yard and get home to watch the World Series. (KGJ.)

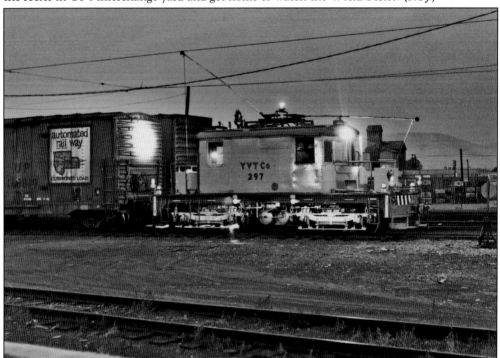

During the fall harvest rush, both 297 and 298 worked, sometimes well after dark. Shippers knew they could call on YVT to bring another reefer to their warehouse on a moment's notice. The 297 is bringing some Union Pacific and Pacific Fruit Express cars into the interchange yard. (Photograph by C. A. Rasmussen.)

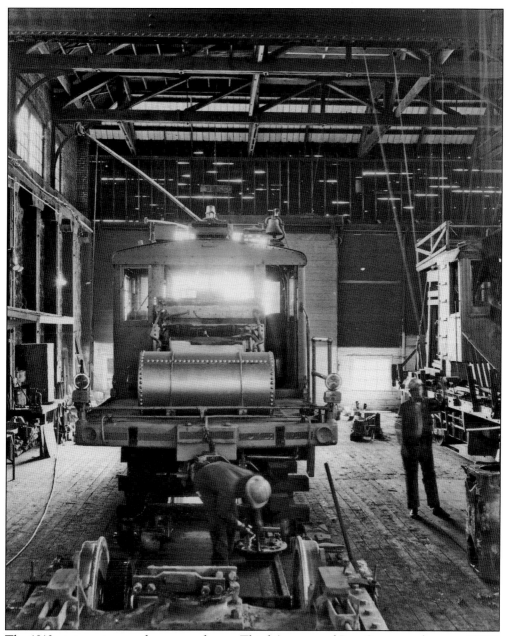

The 1910-vintage stone and masonry shop at Third Avenue and Pine Street was home to YVT's locomotives and the place where they were overhauled. A 15-ton Niles traveling crane, mounted on a track above, could lift the 298 right off its trucks. About the only thing shop forces could not do here was turn wheels on a lathe. (Photograph by C. A. Rasmussen.)

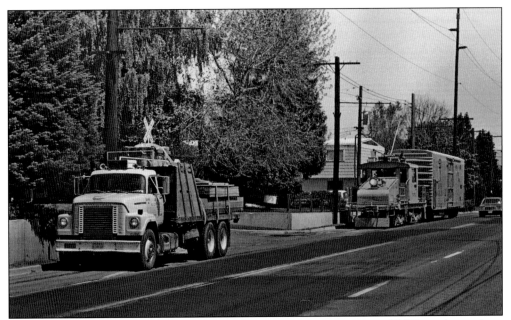

Nob Hill Boulevard was never a delight for either motorists or train crews. YVT's track ran along the north side of the road for many blocks, and its trains surprised more than one motorist not expecting a freight train in the right lane. Similarly, motor vehicles such as the truck here ignored the tracks and parked on them, slowing the train's progress. (KGJ.)

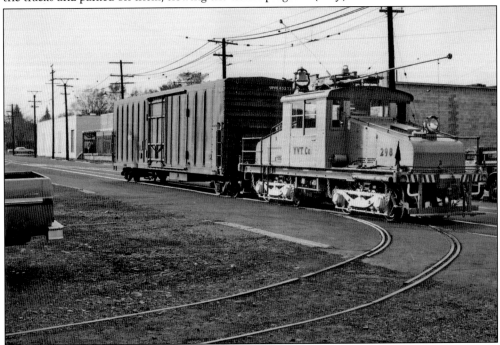

While YVT's fate is being debated at city hall across town, steeple cab no. 298 waits for its crew on Pine Street. The date is November 8, 1971, and YVT's franchise has expired. A vocal minority is trying to persuade the city not to renew. The battle raged on for more than another year, during which time the interurban line operated without a franchise. (KGJ.)

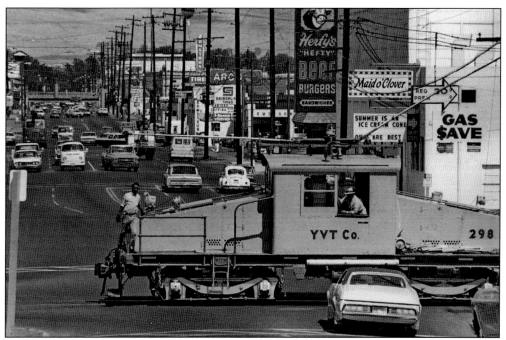

Some Yakimans disliked having electric freight trains on their streets, so in 1971, when YVT's franchise was up for renewal, they formed a Safe Streets Committee to try and get the city council to not renew. Their determination to put YVT in its grave resulted in protracted legal maneuverings that lasted until 1973. Ultimately the ICC ruled that as a common carrier, YVT operation could not be terminated by the city. (Photograph by Ted Benson.)

Flooding in January 1974 washed out sections of the YVT track that passed through Ahtanum. Union Pacific dispatched track crews to quickly get the line rebuilt. By the time the Oporto trolleys arrived in August of that year, the Wiley City line was the smoothest on the railroad. (KGJ.)

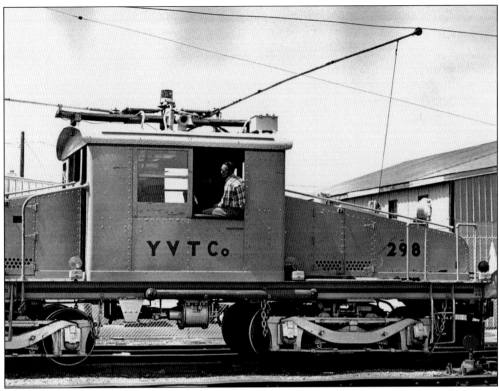

Motorman Mel Lucas watches for the hand signal from brakeman Al Hammermeister in the Union Pacific interchange yard that means pull forward. Motor 298 was YVT's primary locomotive for 63 years, and Lucas worked for the railroad for 19 years. (KGJ.)

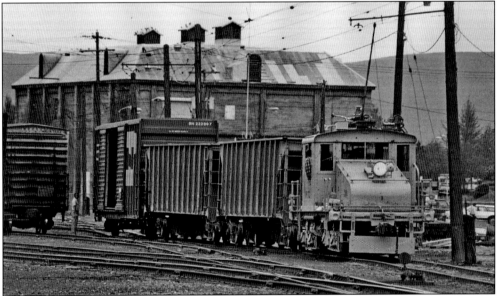

Five of the tracks in Union Pacific's yard in Yakima had overhead wires so that YVT could interchange cars. The 298 is switching cars around on April 22, 1983. The massive building in the background is the former ice plant for Pacific Fruit Express. (KGJ.)

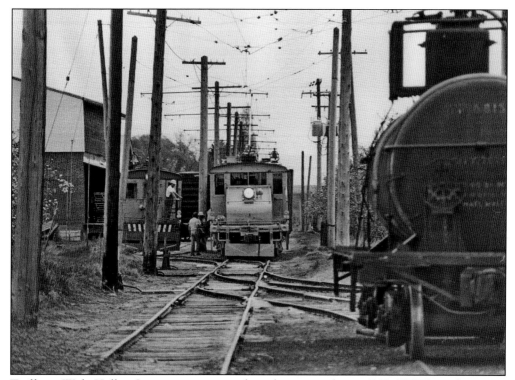

Traffic at Wide Hollow Junction is congested on this spring day in 1983. YVT boxcab no. 297 has taken the hole at Congdon's warehouse while steeple cab no. 298 brings a hopper loaded with crushed rock from town. The crew of 297 is performing maintenance work at the bridge over Wide Hollow Creek. (KGJ.)

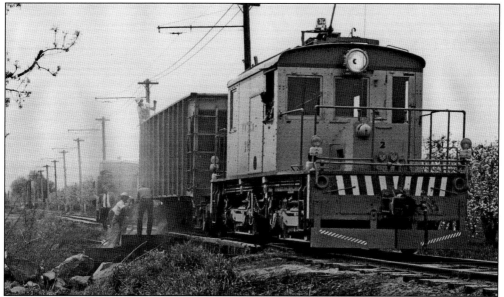

YVT manager Jerry Price (necktie), lineman Dick Noyes (on hopper), and motorman Mel Lucas (in cab) watch as crews dump crushed rock to shore up the Wide Hollow Creek bridge abutments in Congdon's orchards. It is April 22, 1983, and the apple trees are in full bloom. (KGJ.)

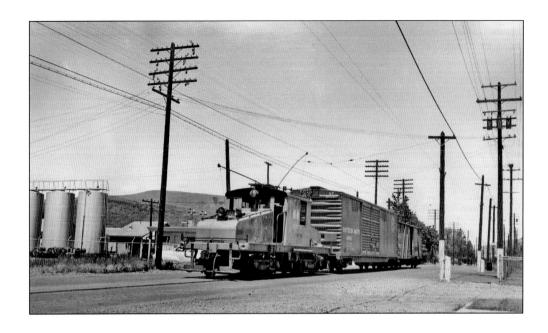

Thirty years separate these photographs. Above, YVT steeple cab motor 298 is bringing in two cars from Yakima Pine Products' door factory on North Sixth Avenue during the 1950s. Below, YVT Trackmobile 296 is performing the same task in 1983. Of the half dozen proposals to convert YVT to diesel, only the Trackmobile experiment of 1983 was ever tried. It was a failure. The Trackmobile did not have enough traction to pull very many cars over YVT's undulating track and sometimes had to make multiple trips to bring in all the freight. After a few months of trying to make it work, YVT sidelined the gnat-like diesel and brought back the electrics, which powered YVT trains until abandonment in 1985. (Above, Charles Smallwood photograph; below, KGJ.)

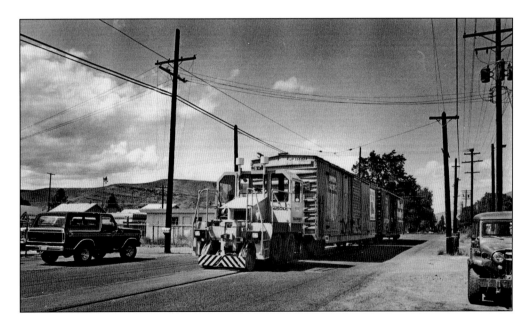

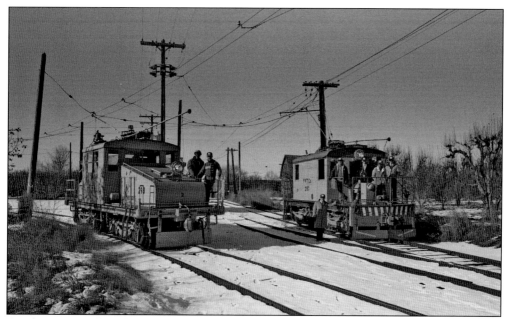

Freight service officially ended on the YVT on November 18, 1985. A final tour of the entire railroad was made using motors 297 and 298. They were packed with Union Pacific officials, YVT crewmembers, trolley coordinator Barb Thompson, and the author. The tour stopped at Wide Hollow Junction so that this official portrait of the event could be made. (KGJ.)

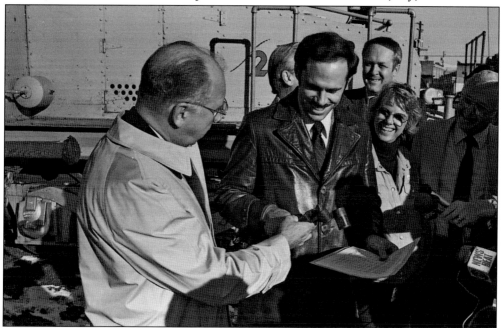

Stan Young (left), representing Union Pacific, hands over the controls for YVT motor no. 298 to city manager Dick Zais, representing the City of Yakima, while trolley coordinator Barb Thompson looks on. This act completed the formal transfer of the YVT to the City of Yakima. The city got a historic trolley railroad, and the Union Pacific got a $1.2-million write-off and did not have to dismantle the railroad, so everyone was happy. (KGJ.)

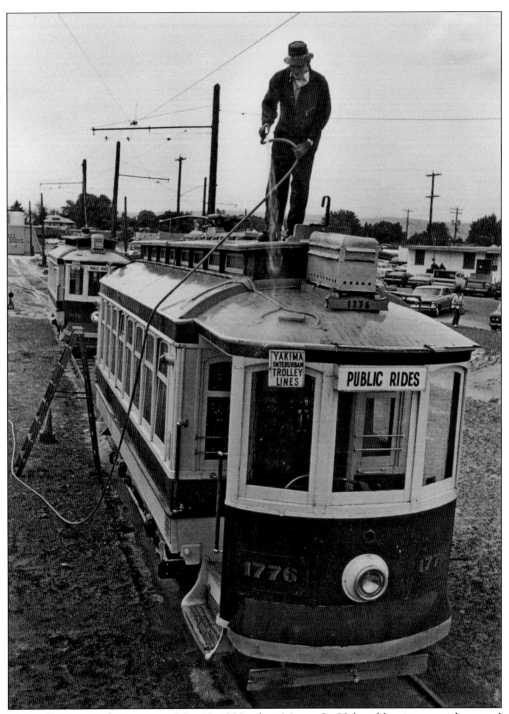

The trolleys stopped running on May 18, 1980, when Mount St. Helens blew its top and covered Yakima with volcanic ash. Operations resumed June 7. The day before resumption, lineman Bob Jones washed down the Oporto cars to prepare them for service. (Photograph by Dean Spuler.)

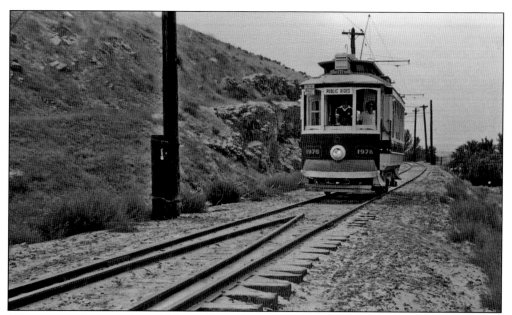

The catastrophic eruption of Mount St. Helens dumped tons of volcanic ash on the Yakima Valley, requiring a massive cleanup operation. Yakima's trolleys were shut down, because ash on the track would get into their motors and ruin them. By the time this view was taken on June 21, rains and cleanup crews had removed enough ash to let the trolleys venture out again. Traces of the ash, however, remained in the rocks and dirt for years thereafter. (KGJ.)

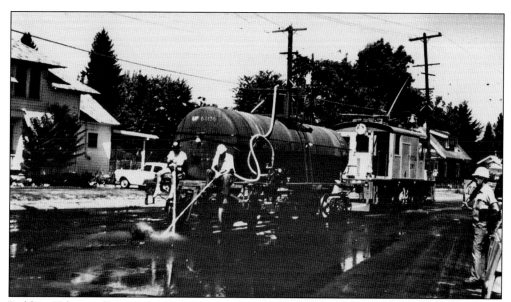

Ridding Yakima of Mount St. Helens' ash was a major challenge in the summer of 1980. Union Pacific brought in a tank car and fitted it with pumps and nozzles. It was pushed along the tracks with two workers riding the end beam and aiming the high-powered water stream at the flangeways to blast the ash out. (Photograph by Art Hamilton.)

The loss of all the west lines is symbolized by this sign strung across YVT track at the entrance to Congdon's orchard in the summer of 1986. YVT's easement over Congdon land was reversionary, and as soon as freight service was no longer offered, the Congdons took it back. A legal battle ensued between the Congdons and the trolley association, represented by Homer Splawn, son of Jack Splawn. The Congdons prevailed. (KGJ.)

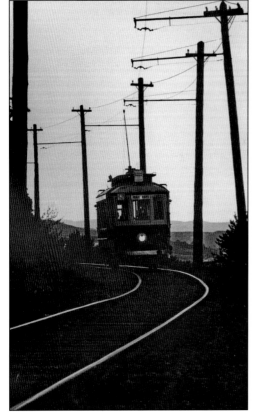

Loss of the west lines in 1986, plus the city's desire to quickly tear up the Nob Hill trackage, limited Yakima's trolleys to operating only on the Selah line. Car no. 1976 is seen here burnishing the rails of Selah Gap as it returns to Yakima on a late afternoon run. (KGJ.)

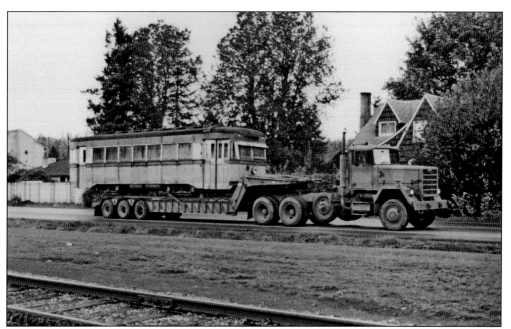

Yakima-bound former YVT Brill Master Unit no. 22 has finished its stint at the railroad museum in Snoqualmie and is heading back to home rails in Yakima in 1989. The U.S. Army from Fort Lewis used moving the streetcars as a training exercise. (KGJ.)

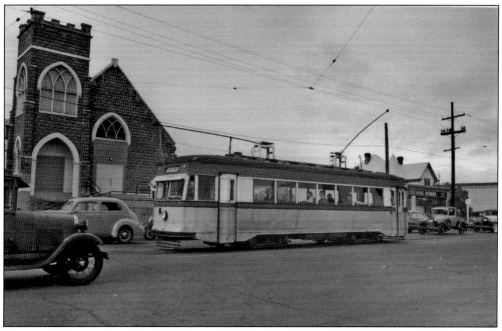

Has the clock turned back to 1947? Master Unit no. 21 returns to YVT rails after a 53-year absence. Yakima's antique car collectors came out en masse to pose for photographs with the vintage trolley. The 21 and sister 22 were on lease to Yakima from Robert Hively. Later, after Hively passed away, the streetcars were purchased from his heirs so they could remain in Yakima. (KGJ.)

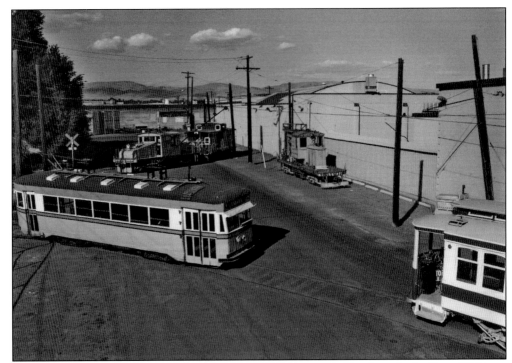

In 1993, Selah wanted to rid itself of YVT tracks and fought a legal battle with the City of Yakima. Eventually most of the track in Selah was given up except for a short portion on the south side of town coming in from Selah Gap. Thus YVT was able to remain a true interurban railroad. The photograph shows the last train to Selah's packing district wye on September 18, 1993. (KGJ.)

Five AmeriCorps volunteers are sworn in by city councilman Lynn Buchanan (second from right) and Ken Johnsen (right) while Yakima Interurban Lines Association (YILA) officials watch. The AmeriCorps volunteers came as part of an ISTEA grant in 1996 that was intended for rehabilitating parts of the YVT. (Photograph by Muriel Ainsworth.)

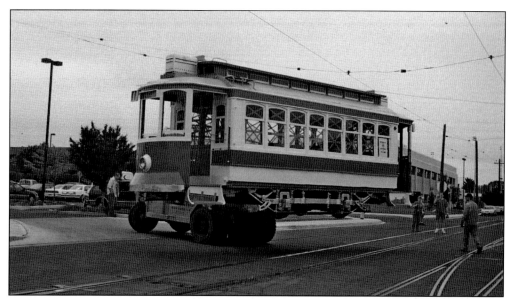

Partly to help the City of Issaquah, Washington, and partly to get it out of the hands of the troubled YILA, Yakima loaned its Oporto trolley no. 1976 to the Issaquah Valley Trolley Association in the late fall of 2000. Eighteen months after helping Issaquah launch its trolley service, the 1976 was returned to Yakima, as seen here in May 2002. (Photograph by John Ainsworth.)

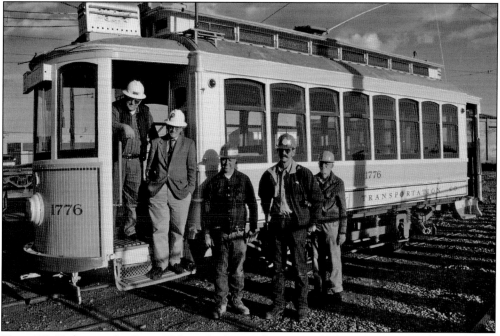

Upon YILA's demise, the City of Yakima had Ken Johnsen, Paul Edmondson, and Jerry Henderson set up a new trolley organization, the Yakima Valley Trolleys, in 2001. The first order of business was completing YILA's unfinished restoration of Oporto car no. 1776, because no. 1976 was still on loan to Issaquah. The 1776 was painted in original 1908 YVT colors. From left to right, Jerry Henderson, Paul Edmondson, David Klingele, Rich Rowland, and John Ainsworth pose on the completed trolley. (KGJ.)

Homer Splawn, the last surviving offspring of YVT's first president, Jack Splawn, lived to attend the railroad's centennial in 2007. He is seen here being interviewed by Wes Nelson of the *Yakima Herald-Republic* in 2001. (Photograph by Yvonne Wilbur.)

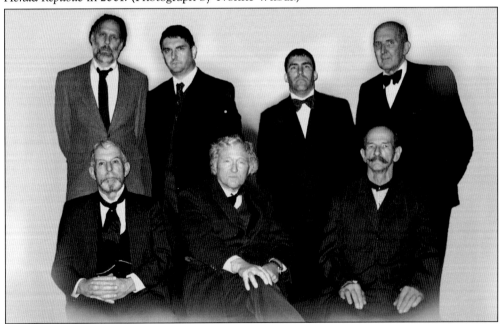

A centennial celebration was held on December 22, 2007, exactly 100 years after the first trolley turned a wheel in Yakima. To commemorate the occasion, the modern board of directors staged a photograph like the one of the original directors on page 13. From left to right are (seated) Larry Perrigo, Paul Edmondson (vice president), and Rich Rowland; (standing) Phil Hoge (treasurer), Scott Neel (secretary), Joe Rief, and Dr. Ken Johnsen (president). (AC.)

During a period of high flux in the value of copper, thieves stole a substantial amount of copper wire from YVT's Selah line, temporarily putting it out of operation. With aid from the city, Puget Sound Energy, and the Edmonton Radial Railway Society, new wire and hardware was obtained, and an alarm system was developed to foil future theft attempts. (KGJ.)

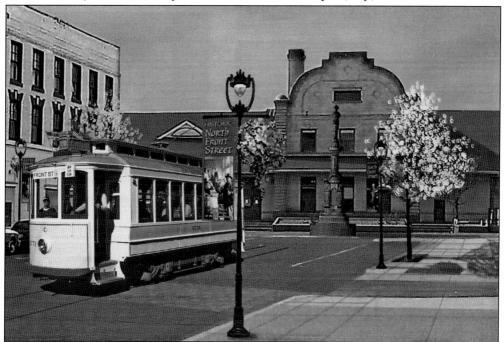

This artist's rendition of how the Yakima trolley could become a part of the Front Street redevelopment envisions an extension from the historic Front Street line going up A Street to the Convention Center. The city has looked at several different scenarios for running the YVT tracks across or under the BNSF tracks to once again serve the east side of town. (AC.)

A goal of the Yakima Valley Trolleys organization is museum development, and it takes many forms. One form of getting the message of historic importance to visitors is the Actors Group. Costumed time travelers board the trolley at random times and talk with riders about the railroad as if it were during their age. Flapper Crystal Knoblaugh sings to her riders and tells them YVT anecdotes as though it were the 1920s. (KGJ.)

Five

ROSTER AND

INFRASTRUCTURE

The elements—past and present—that make up the Yakima Valley Transportation Company are presented in this chapter. The YVT is very typical of the many hundreds of electric interurban railroads that sprang up around the United States and Canada at the beginning of the 20th century. What sets it apart from all the others is the fact that it somehow survived, unchanged and intact, into the modern era. The track, overhead power system, powerhouse, carbarn, line car, and other elements look today just as they did over 100 years ago. That is why it is listed on the National Register of Historic Places.

This book is the follow-on to *Apple Country Interurban*, published in 1979. Every effort has been made to ensure the accuracy of this updated roster and associated information. YVT and Union Pacific company records have been studied, interviews with old-timers have been recorded, and newspaper accounts have been pored over. The author solicits corrections or additions to the information presented here, and can be contacted at P.O. Box 161, Renton, WA, 98057. It is entirely likely that in years to come, a follow-on to this book will be produced, possibly in an electronic format that will include motion pictures that still exist of the YVT. New information and pictures are always welcome.

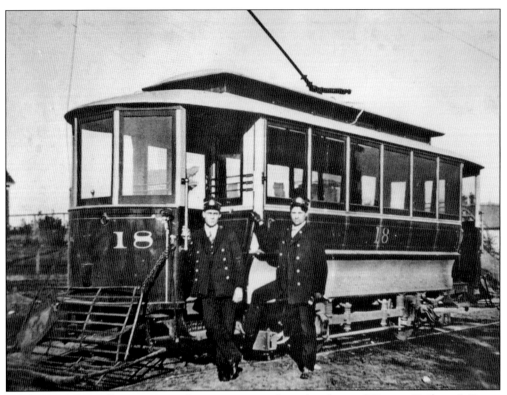

While YVT's Danville cars were under construction, the railroad rented Tacoma Railway & Power single-truck cars no. 18 and 36 to open service. They arrived in Yakima on December 5, 1907, and were shipped back to Tacoma on October 22, 1908. (Lawton Gowey collection.)

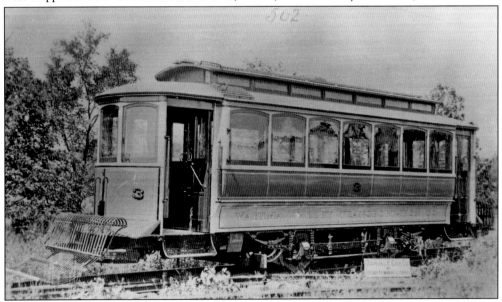

The initial three built-for-Yakima cars arrived from Danville Car Company on September 16, 1908. Nos. 1 and 2 were retired November 12, 1926; no. 3 made its last run on March 20, 1930, in service for welding work. These cars had smaller vestibules than subsequent single-truck cars. (AC.)

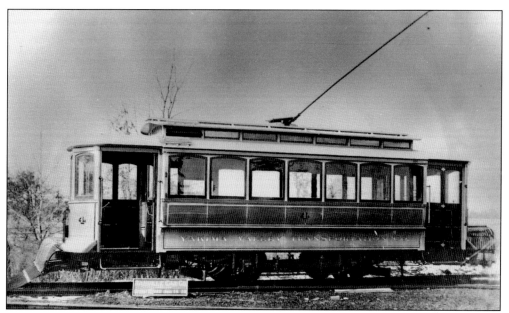

Nos. 4 and 5 were YVT's second order of cars from Danville and were a foot and a half longer than the original cars. They arrived in mid-January 1910. No. 4 made its last run on February 14, 1930, and no. 5 had its last run on March 6 of the same year. (Lawton Gowey collection.)

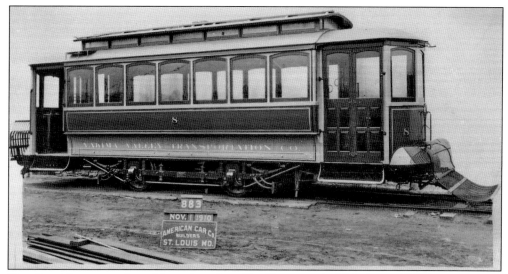

Nos. 8 and 9 were purchased from American Car Company in 1910, during YVT's great time of expansion. They were the longest of the single-truck cars. Number 8 was last used on October 28, 1929, and no. 9 had its last run on January 16, 1929. (Edward B. Watson collection.)

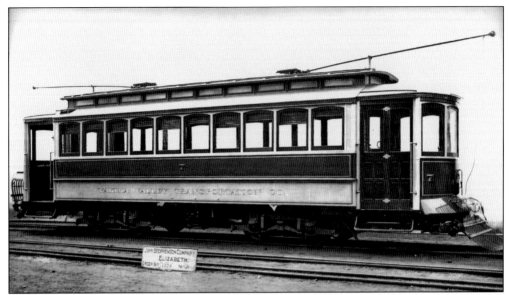

This builder's photograph shows no. 7 in its as-built yellow paint scheme. The bumpers were painted red. No. 7 was YVT's longest-lived streetcar, having been in service from 1910 until its last run on February 1, 1947. The 6 and 7 were the first YVT streetcars to have air brakes. (AC.)

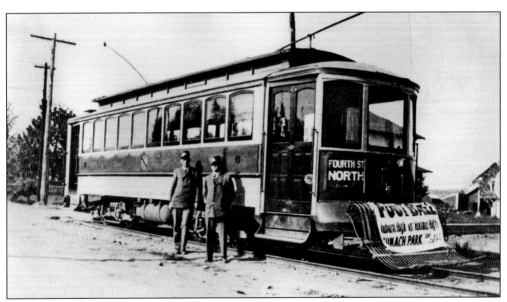

Motorman Mark Graves (left) and conductor Pat Potter pose alongside YVT no. 6. For a while, YVT used a circular emblem, as seen on the side of the car. It contained the letters "YVT" in a diagonal band. No. 6 broke an axle shortly before the final parade of February 1, 1947, and was not able to participate. (Bob Lince collection.)

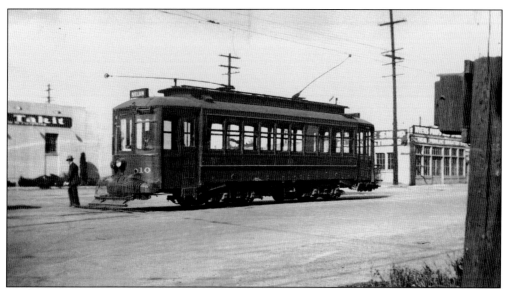

YVT supplemented its fleet with two used cars from Yonkers Street Railway Company of Yonkers, New York, in 1914. Nos. 10 and 11 were the first four-motored cars in city use. They were not very well liked and were retired in 1939. (RSW.)

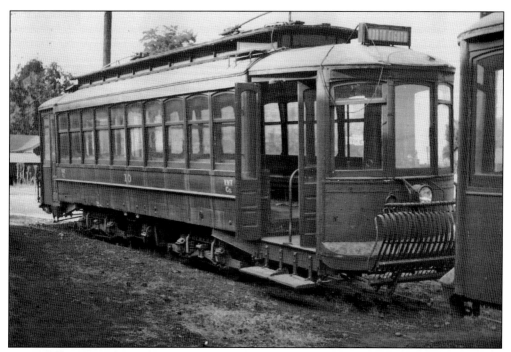

Hunter Illuminated car signs were applied to YVT's streetcars and interurbans in 1917. YVT nos. 10 and 11 were Yonkers cars 148 and 149 respectively. There is no evidence to show that they were ever painted in YVT's yellow paint scheme. Both cars had air brakes. (Photograph by Charles Smallwood.)

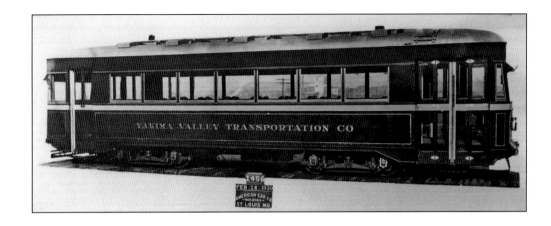

YVT's modern Brill Master Units were the perfect antidote to the clattering old wooden trolleys used up until 1930. They were sleek and quiet. Electric heaters kept the interiors warm in the winter. For a time, they revived passenger service. They made their first revenue runs on March 9, 1930, and all three finished their first career on YVT on February 1, 1947. No. 21 would make a return engagement in the fall of 1989 and is still operational today in Yakima. No. 22 is at Yakima but not operational. Above is an as-built photograph, and the photograph below shows the final paint scheme used in the late 1930s and 1940s. (Both, AC.)

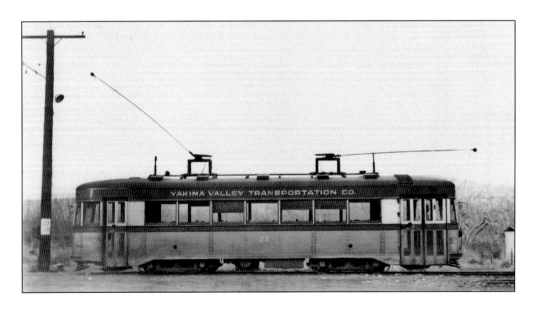

With the Master Units, the days of rattan benches and dark, drafty interiors were gone. This builder's photograph shows the comfortable leather seats and abundant lighting on the ceiling that made these cars an instant hit with riders. YVT was the second railroad in the country to obtain the Master Units, making it at the time one of the country's most modern streetcar lines. (AC.)

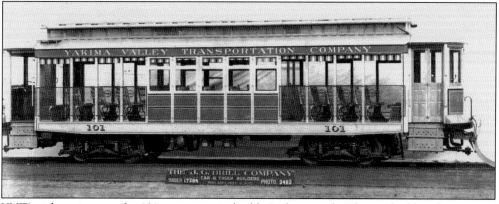

YVT's sightseeing car, the 101, is seen in its builder's photograph. The car had bench seats and convertible side panels that could be removed during warm summer weather. It was very popular when introduced in 1910 but soon became outmoded by automobiles and made its final run on September 14, 1929. It was scrapped in early 1930. (AC.)

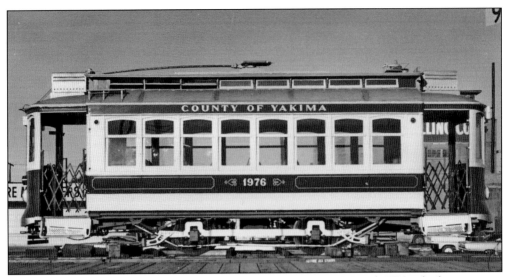

The last city streetcars to arrive on YVT property were nos. 1776 and 1976, which came into town riding a Union Pacific freight train on August 28, 1974. The numbers reflect the fact that they were Yakima's bicentennial project. The city and the county contributed $7,500 each toward the purchase, and the Bicentennial Commission gave $1,000. The rest of the estimated $41,000 cost came from private donations. The cars are the Brill semi-convertible type with cane rattan seats, constructed in Oporto, Portugal. They are still in service as of this writing and will soon become the longest-lived cars on YVT. (Both, KGJ.)

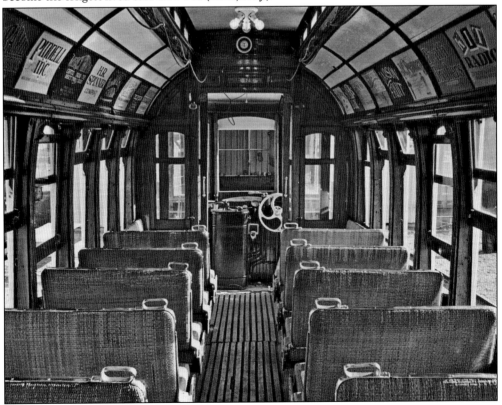

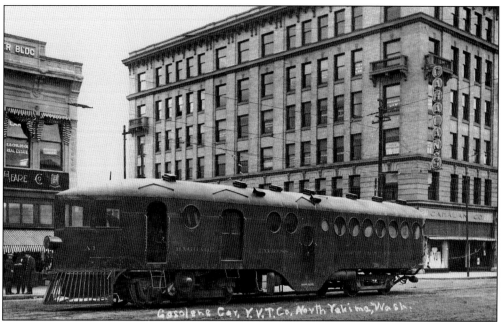

Two McKeen gasoline mechanical cars were used by the YVT to open interurban service in 1910, prior to the arrival of electric cars from Niles. Owned by YVT's parent North Coast Railway (Union Pacific), they were originally numbered A1 and A2. After YVT service, they became OR&N 602 and 603, ultimately becoming Union Pacific M-78 and M-79. They were scrapped in 1934. (YVM.)

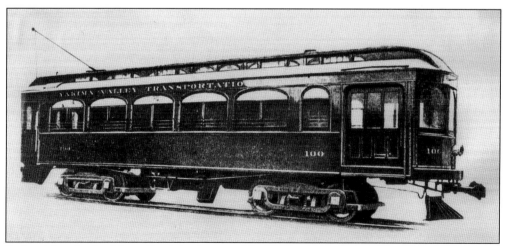

Ordered shortly after Union Pacific's takeover of the YVT in 1909, the Niles combination passenger/baggage interurban car was a classic car of the day. The builder's photograph interestingly does not show it in its original yellow paint scheme. The baggage compartment could hold a coffin, and YVT provided for carrying the deceased, when accompanied by a fare-paying person, to the cemetery siding at Twenty-fourth Avenue and Nob Hill Boulevard. (Lawton Gowey collection.)

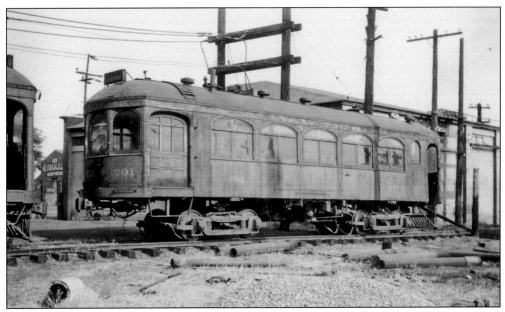

Following the cessation of interurban service in 1935, interurban cars 100, 200, and 201 languished in the YVT yards for several years. No. 201, once stately and elegant, is seen here on the scrap line in August 1939. Within a couple months, it would be only a memory. (RSW.)

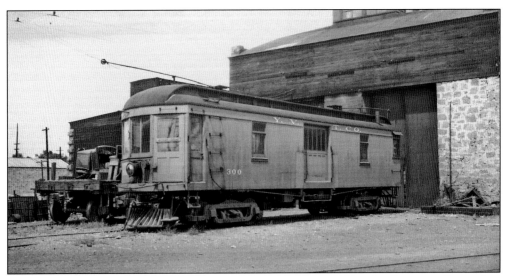

Express motor no. 300 was part of YVT's original 1909 order from Niles Car Company. Expanding freight service soon made this car obsolete, and it was relegated to maintenance-of-way service. It was scrapped in November 1956. Only the line car no. A still exists of the original 1909 interurban equipment procured by the YVT. (Photograph by Harold Hill.)

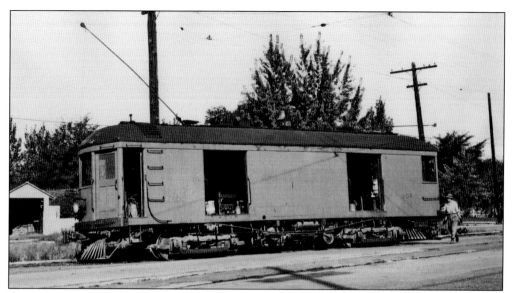

Jewett express motor 301 survived until 1972. It was replaced in March 1969 by truck A6 and donated a year later to the Rotary Club for a charity auction. It was auctioned for $510 to the trolley museum at Rio Vista, California, who scrapped it and used the trucks and electrical gear in the restoration of their Petaluma & Santa Rosa interurban car. (Photograph by Charles Smallwood.)

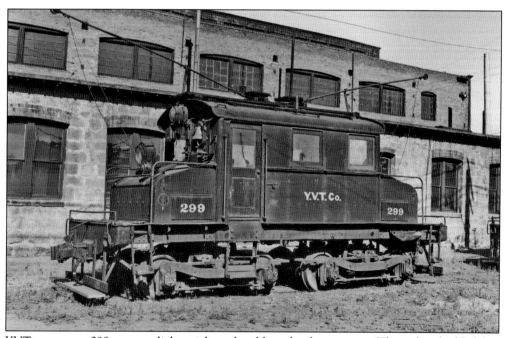

YVT motor no. 299 was too lightweight to be able to haul many cars. The railroad added five tons of pig iron on each end in an attempt to gain more traction, but once no. 298 arrived on the property, the aging 299 fell into secondary use. It was taken out of service March 10, 1948, and finally scrapped in August 1958. (Photograph by Charles Smallwood.)

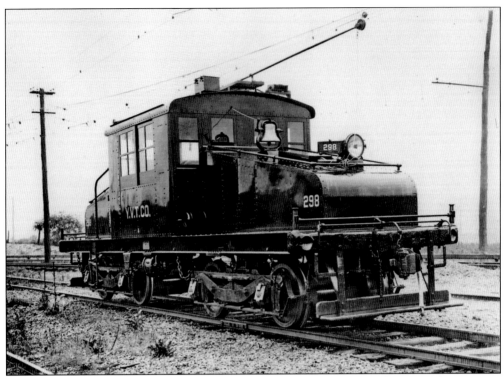

YVT 50-ton steeple cab motor no. 298 posed for its builder's photograph on October 7, 1922, at General Electric's Erie Works. Upon entering service, it displaced the older locomotives and became the railroad's freight mainstay for the next 63 years. It is still operable in Yakima today. (Donald Duke collection.)

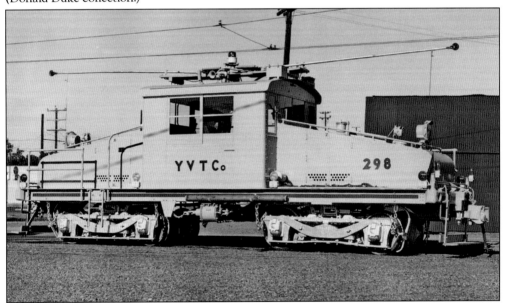

No. 298 exchanged its black paint scheme for a yellow-and-black scheme in the 1950s. The 298 and all YVT locomotives got the full Union Pacific color scheme in the 1970s, as seen here. Crews liked the visibility from its center cab more than that of the 297. (KGJ.)

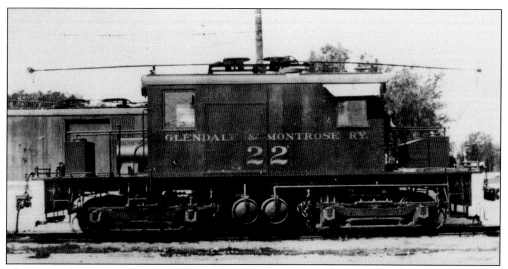

The newest electric motor on the YVT was the 297, which was built as Glendale & Montrose (G&M) no. 22. When Union Pacific took over the G&M in 1931, the locomotive was renumbered Union Pacific E-100. When Union Pacific dieselized the former G&M, it was transferred to Yakima (in 1942) and renumbered once again, to YVT no. 297. YVT paid $9,411 for the box motor. (AC.)

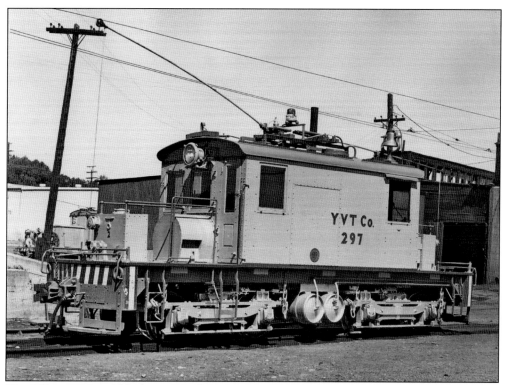

The 297 was painted black in its early years on YVT. Some time in the 1950s, it was painted yellow with a black roof and trim. In 1971, it and the other YVT locomotives were given the full Union Pacific treatment of armour yellow, gray, and red trim with silver trucks. Even the lettering was made from Scotchlight. (KGJ.)

YVT no. A looked like this builder's photograph until 1922. It was used in the early days as a locomotive, but when the steeple cab 298 arrived, the A was rebuilt into a line car and entered work service. It arrived in Yakima on July 1, 1910, and has been used continuously ever since. Before Union Pacific's 1985 abandonment, the A was the oldest operational locomotive owned by a Class I railroad in the United States. (AC.)

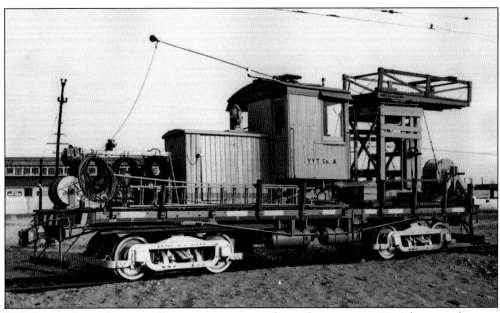

YVT line work was done initially on a tower on top of rented streetcar no. 18. A homemade tower car on a shop bogey was used after no. 18's departure. In 1922, the homemade car was scrapped, and the no. A was outfitted with a swiveling tower, wire spool supports, and a cabinet for carrying hardware used in overhead wire construction. It is still used in this capacity today. (KGJ.)

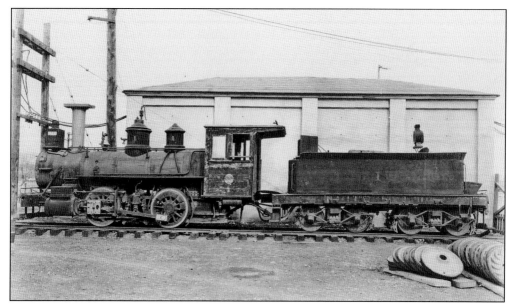

YVT purchased 0-4-0 no. 1 from Terre Haute & Indianapolis railroad in August 1909 for $3,500. It was used in track construction where overhead wire was not yet strung. In late 1910, parent North Coast Railway borrowed it for construction of their line up the valley to Yakima. It was sold to a logging railroad in Cle Elum in 1922 and eventually ended up being scrapped in Seattle. (AC.)

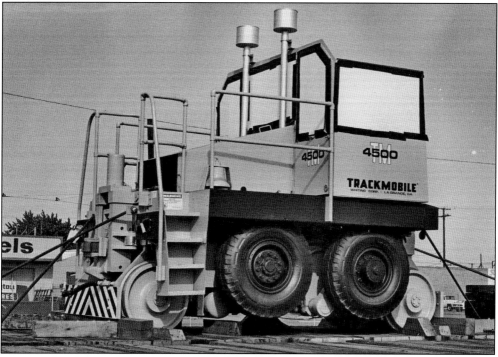

YVT Trackmobile no. 296 arrived in Yakima on May 12, 1983, and left town two years later on November 19. It was not able to fulfill the railroad's goal of taking over freight service from the electric locomotives because it was too lightweight. After several months of unsuccessful tests, it was sidelined, and the electrics once again moved the freight. (KGJ.)

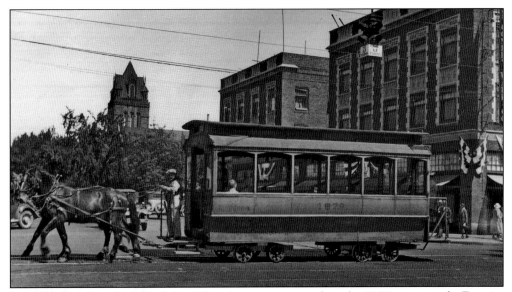

For three days, May 17 through 19, 1935, a horse car operated on the YVT as a stunt for Frontier Days. It was made from the body of retired Seattle Muni streetcar no. 107 and kept its orange Seattle colors. Following Frontier Days, it was stored at the fairgrounds for a number of years. Its final disposition is unknown. (RSW.)

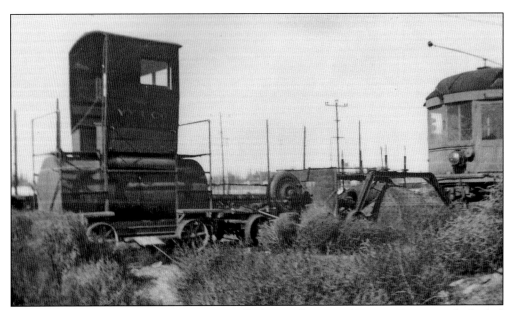

YVT no. A-1 was a three-part contraption called a Woolery Weed Burner. It consisted of a fuel tank, a burner, and a hood that spread the flames over the track to kill weeds. The railroad purchased it in May 1926 and scrapped it in November 1942. (RSW.)

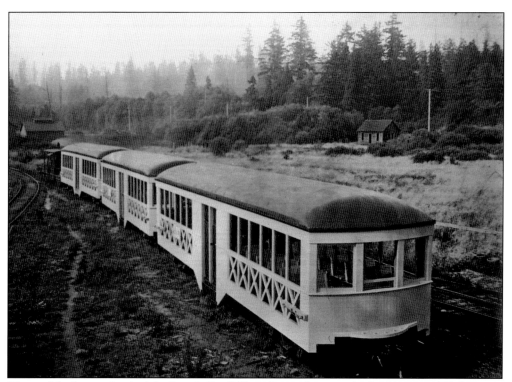

Three of the four trailers built by Seattle Car & Foundry are shown at the firm's Renton, Washington, plant, ready for delivery to YVT. Their seats could be removed to accommodate 150 standing riders or less-than-carload freight. The cars were used during Fair Week and for special excursions. Declining patronage soon rendered them obsolete. (AC.)

YVT's standee trailers ended their days in the woods above Cle Elum hauling lumberjacks to work for the Cascade Lumber Company at Squawk Creek. (RSW.)

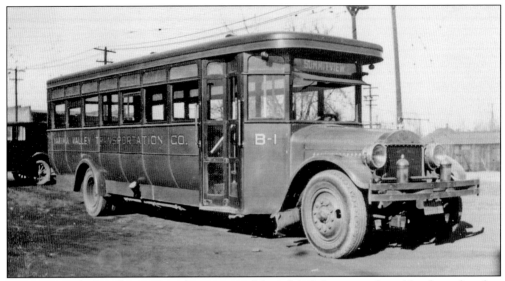

Mack B-1, parked in the YVT yards, was one of three Mack buses purchased by the railroad in 1926 in order to try out bus replacements for streetcars. They weren't too successful, and buses did not totally supplant the streetcars until February 1947. (AC.)

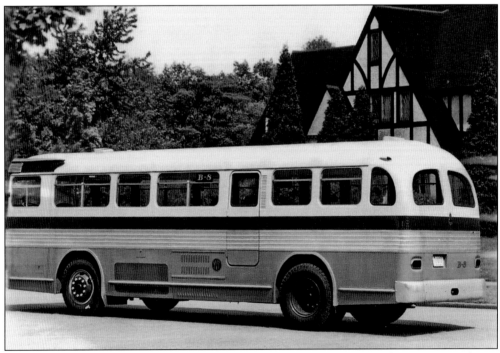

YVT was a good customer of Twin Coach, ultimately owning 18 of their products. No. B-8, shown in this builder's photograph, has an interesting YVT emblem just ahead of the door but no Union Pacific heralds as yet. (Jerry Fretto collection.)

YVT has used at least seven trucks over the years. International Harvester no. A7 was donated to the City of Yakima along with all the rest of the locomotives, machinery, and physical plant in 1985. (KGJ.)

The one-ton 1950 Dodge, no. A4, was purchased in 1954 and used by lineman Bob Jones to go out and work on repairs anywhere on the railroad. Jones began working on the YVT in 1944 and kept at it for over 30 years. (KGJ.)

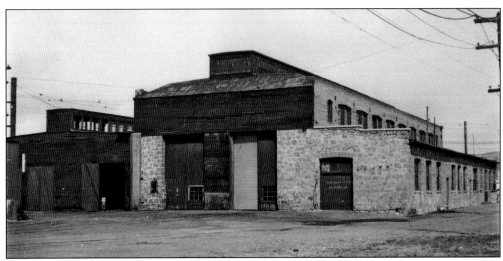

In August 1910, YVT built a sandstone and brick car shop and adjacent barn at a cost of $30,000. The shop building, which is still in use a century later, boasts a machine shop, forge room, and overhead crane and takes care of all repairs to YVT rolling stock. It has two tracks with pits and a small office. (KGJ.)

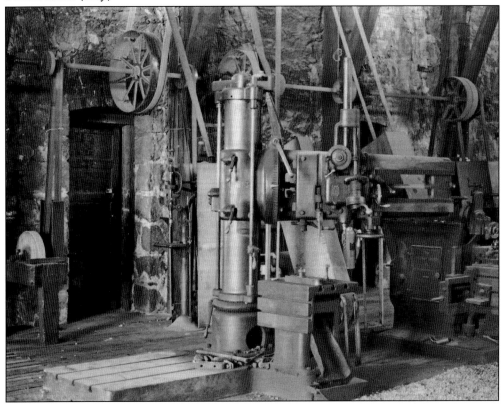

The entire YVT machine shop was powered by one electric motor. Power was delivered to each machine via a belt drive system that could be engaged to any one machine via a simple clutch mechanism. As parts became harder to find, the YVT shop men had to resort to fabricating more and more of their parts. (KGJ.)

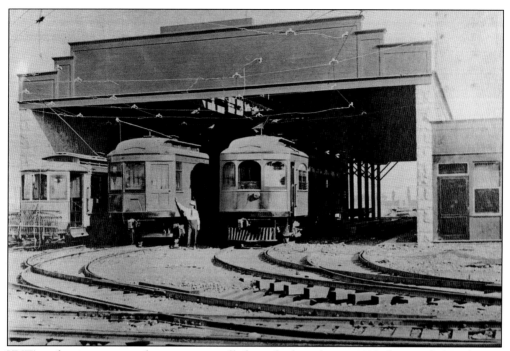

YVT's carbarn, or running barn as it was called, was built in August 1910 along with the adjacent shop. It had four tracks and was used for storage of streetcars, interurbans, and locomotives. In later years, it was used for bus and truck storage. It was torn down exactly 66 years after it was built. (YVM.)

This view of the running barn from the southwest was taken in 1969. The chimney comes from the boiler room, where heat was generated for the running barn and adjacent main shop building. Seven years later, the running barn was condemned and razed. (Photograph by Hilding Larson.)

In 1911, YVT built this poured concrete powerhouse near the carbarn to provide electricity for the trolley system. Two large motor-generators and associated switching gear converted AC electricity from the power company to 600 volts DC for the trolleys. They were the main source of energy until a rectifier system was installed in the late 1970s. A business office and vault were also part of this building. (KGJ.)

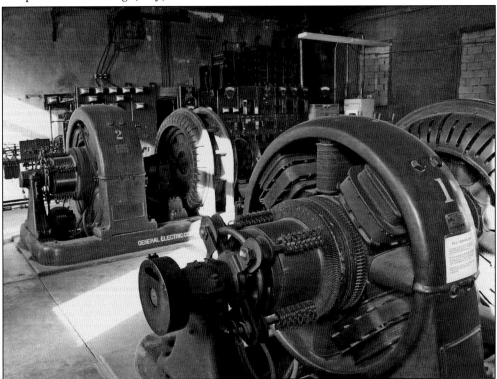

Power dynamos in the YVT powerhouse at Third Avenue and Pine Street converted AC electricity purchased from the power company to 600 volts DC for the trolley system. At one time, there was a plan to up the voltage on the interurban lines to 1,200 volts DC, but it was never needed. YVT replaced the dynamos with rectifiers in 1979 but left them and their switching gear intact in the powerhouse. (KGJ.)

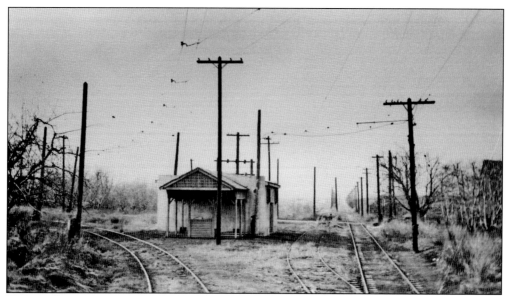

Wide Hollow Junction, located on Congdon's orchards along Sixty-fourth Avenue, was where the line to Wiley City separated (to the left) from the line to Henrybro. The small building (which was built in 1922 and still stands) housed a substation with a motor-generator set, switching equipment, and later a rectifier. The photograph dates to about 1940. (AC.)

The stately building at 104 West Yakima Avenue was built by the Union Pacific to house their offices and those of the YVT. Union Pacific Overland heralds adorn the top. The closest corner on the second floor was occupied by YVT's manager. Corporate offices for the YVT were located in Portland, Oregon. Records of the railroad were stored in triplicate in this office, the substation vault, and the Portland offices. (KGJ.)

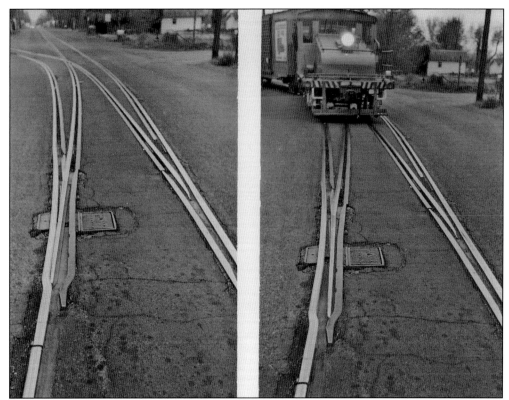

An economical switch for in-street running was this single point switch utilized by the YVT in many locations in the early days. The switch pictured was the last one in use on the YVT, along North Sixth Avenue, and was taken out of service in the late 1990s, when its siding was no longer needed. (KGJ.)

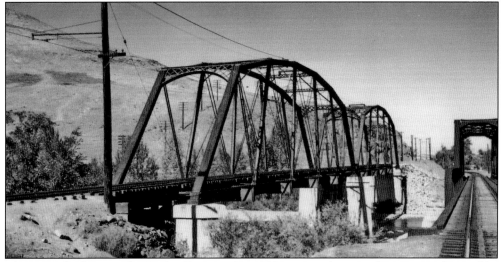

The YVT's bridge over the Naches River in this 1948 vintage photograph is not yet obscured by the trees there today. It is a rare Pegram Truss bridge that was built for Union Pacific's crossing of the Blue River at Manhattan, Kansas, in 1895 and later replaced with a larger one. It was shipped to YVT in 1912 in kit form for use on the Selah Line. (Photograph by Bruce Holcomb.)

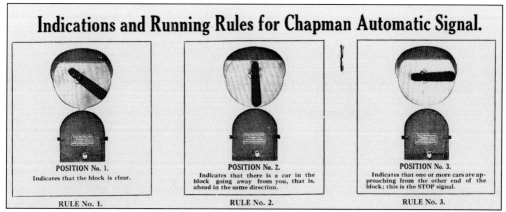

Indications and Running Rules for Chapman Automatic Signal.

POSITION No. 1.
Indicates that the block is clear.

POSITION No. 2.
Indicates that there is a car in the block going away from you, that is, ahead in the same direction.

POSITION No. 3.
Indicates that one or more cars are approaching from the other end of the block; this is the STOP signal.

RULE No. 1.

RULE No. 2.

RULE No. 3.

YVT installed the Chapman Automatic Signal system along its lines in August 1914. This illustration from the Chapman Signal catalog shows the meaning of each semaphore position: 1. At angle. The block is clear; 2. Straight down. Another car is in the block going away from you; 3. Horizontal. Stop! One or more cars are approaching from the other end of the block. By the 1970s, the system was obsolete. (AC.)

The key on the left unlocks YVT switch locks. The baggage tag on the right is reported by its owner to have been used on interurban routes such as the Wiley City line. (Scott Neel collection.)

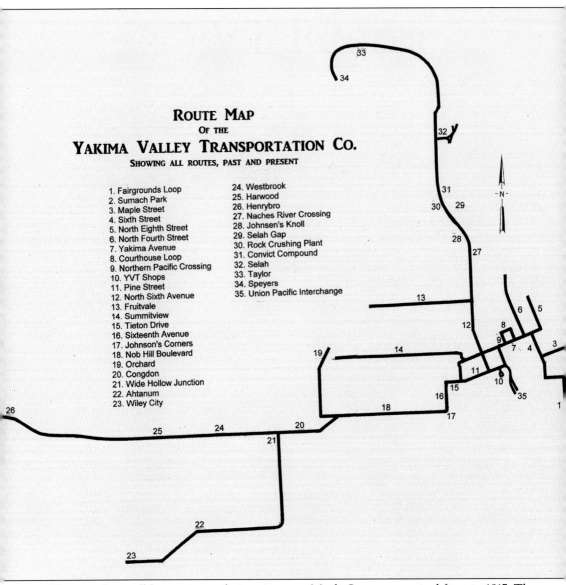

ROUTE MAP
OF THE
YAKIMA VALLEY TRANSPORTATION CO.
SHOWING ALL ROUTES, PAST AND PRESENT

1. Fairgrounds Loop
2. Sumach Park
3. Maple Street
4. Sixth Street
5. North Eighth Street
6. North Fourth Street
7. Yakima Avenue
8. Courthouse Loop
9. Northern Pacific Crossing
10. YVT Shops
11. Pine Street
12. North Sixth Avenue
13. Fruitvale
14. Summitview
15. Tieton Drive
16. Sixteenth Avenue
17. Johnson's Corners
18. Nob Hill Boulevard
19. Orchard
20. Congdon
21. Wide Hollow Junction
22. Ahtanum
23. Wiley City

24. Westbrook
25. Harwood
26. Henrybro
27. Naches River Crossing
28. Johnsen's Knoll
29. Selah Gap
30. Rock Crushing Plant
31. Convict Compound
32. Selah
33. Taylor
34. Speyers
35. Union Pacific Interchange

The map shows all lines prior to their retirement. Maple Street was retired first, in 1917. Then North Fourth Avenue bit the dust in 1919. Twelfth Avenue followed in 1921. Courthouse (B Street) Loop was abandoned in 1930 and taken up in 1942 along with Summitview Boulevard, Eleventh Avenue, Twelfth Avenue, Yakima Avenue between Sixth Avenue and Twelfth Avenue, and South Sixth Street. The Fairview line was torn up in 1938. Selah to Speyers went in April 1943. Everything east of Sixth Avenue was torn up in the summer of 1947, and everything west of Johnson's Corners was abandoned in 1986. Tieton Drive and Sixteenth Avenue were the last to go in 1988. Let there be no more abandonments! (KGJ.)

YVT ROSTER

YAKIMA VALLEY TRANSPORTATION COMPANY ALL-TIME EQUIPMENT ROSTER

Number	Built–Retired	Builder	Notes
		STREETCARS	
1	Sept. 1908–1926	Danville	S.T. Longitudinal seating. Scrapped.
2	Sept. 1908–1926	Danville	S.T. Longitudinal seating. Scrapped.
3	Sept. 1908–1930	Danville	S.T. Longitudinal seating. Scrapped.
4	Jan. 1910–1930	Danville	S.T. Longitudinal seating. Scrapped.
5	Jan. 1910–1930	Danville	S.T. Longitudinal seating. Scrapped.
6	Aug. 1910–July 1947	Stephenson	D.T. Air brakes. Sold to Valley Junk.
7	Aug. 1910–July 1947	Stephenson	D.T. Air brakes. Sold to Valley Junk.
8	Aug. 1910–1930	American	S.T. Longitudinal seating. Scrapped.
9	Aug. 1910–1930	American	S.T. Longitudinal seating. Scrapped.
10	1904–Oct. 1939	Stephenson	D.T. Air brakes. Ex-Yonkers No. 148. Purch. Apr. 1914.
11	1904–Oct. 1939	Stephenson	D.T. Air brakes. Ex-Yonkers No. 149. Purch. Apr. 1914.
18	?–?	Brill	S.T. Rented from Tacoma Railway & Power.
20	Mar. 1930–	Brill	D.T. Sold Sept. 1947 to Portland Traction Co. No. 4008.
21	Mar. 1930–	Brill	D.T. Sold Sept. 1947 to Portland Traction Co. No. 4009.
22	Mar. 1930–	Brill	D.T. Sold Sept. 1947 to Portland Traction Co. No. 4010.
36	?–?	Brill	S.T. Rented from Tacoma Railway & Power.
1776	1928–	STCP/Brill	S.T. Ex-Oporto No. 254. Bicentennial trolley.
1976	1928–	STCP/Brill	S.T. Ex-Oporto No. 260. Bicentennial trolley.
		HORSE CAR	
107	1900–1935	Jackson and Sharp	S.T. Purch. from Seattle Municipal Railway.
		SIGHTSEEING CAR	
101	June 1910–1930	Brill	52 seats. Convertible "Seeing Yakima Car."
		GASOLINE MECHANICAL CARS	
A-1	Mar. 1910–Sept. 1934	McKeen	S.N. 68. Rented from North Coast Railway.
A-2	Mar. 1910–Sept. 1934	McKeen	S.N. 66. Rented from North Coast Railway.
		INTERURBAN PASSENGER AND EXPRESS CARS	
100	July 1910–July 1947	Niles	Comb. passenger-baggage. Sold to Valley Junk.
200	Dec. 1913–Oct. 1939	Jewett	Comb. passenger-baggage. Scrapped.
201	Dec. 1913–Oct. 1939	Jewett	Comb. passenger-baggage. Scrapped.
300	July 1910–Nov. 1956	Niles	Express. Scrapped.
301	Dec. 1913–Mar. 1970	Jewett	Express. Scrapped at Rio Vista, CA, for parts.
		ELECTRIC LOCOMOTIVES	
297	Aug. 1923–	Baldwin/Westinghouse	S.N. 56937. Orange Empire Museum.
298	Sept. 1922–	General Electric	S.N. 8788. Operational, Yakima.
299	1907–Oct. 1958	Baldwin/Westinghouse	S.N. 32061. Scrapped.
		DIESEL LOCOMOTIVE	
296	May 1983–Nov. 1985	Whiting	S.N. LGN 952350483. Transferred to California.
		STEAM LOCOMOTIVE	
1	Oct. 1889–1922	Vandalia Shops	S.N. V-A.2. Terre Haute & Indianapolis RR. Sold.
		WORK CAR	
A	July 1910–	Niles	Converted to line car, 1922. Operational, Yakima.
		PASSENGER TRAILERS	
50	1914–1922	Seattle Car & Foundry	Sold to Cascade Lumber Co. Cle Elum.
51	1914–1922	Seattle Car & Foundry	Sold to Cascade Lumber Co. Cle Elum.
52	1914–1922	Seattle Car & Foundry	Sold to Cascade Lumber Co. Cle Elum.
53	1914–1922	Seattle Car & Foundry	Sold to Cascade Lumber Co. Cle Elum.

FLATCARS

1000	1910–Mar. 1957	Seattle Car & Foundry	Scrapped.
1001	1910–Mar. 1957	Seattle Car & Foundry	Scrapped.
1002	1910–Mar. 1957	Seattle Car & Foundry	Scrapped.
1003	1910–Mar. 1957	Seattle Car & Foundry	Scrapped.
1004	1910–Mar. 1957	Seattle Car & Foundry	Scrapped.
1005	1910–Mar. 1957	Seattle Car & Foundry	Scrapped.
1006	1910–Mar. 1957	Seattle Car & Foundry	Scrapped.
1007	1910–Mar. 1957	Seattle Car & Foundry	Scrapped.
1008	1910–Mar. 1957	Seattle Car & Foundry	Scrapped.
1009	1910–Mar. 1957	Seattle Car & Foundry	Scrapped.
1010	1910–Mar. 1957	Seattle Car & Foundry	Scrapped.
1011	1910–Mar. 1957	Seattle Car & Foundry	Scrapped.
1012	?–Mar. 1957	?	Scrapped.
1013	?–Mar. 1957	?	Scrapped.
1014	May 1928–	Bettendorf Company	Boom car. Ex–Union Pacific 55831.
1015	1926–	Bettendorf Company	Ex–Union Pacific 55838.

BOXCAR

100	Before 1910–?	?	Used. Rebuilt 1912, renumbered 400.

WEEDBURNER

A-1	May 1926–Nov. 1942	Woolery	Three-unit weedburner. Scrapped.

SPEEDER

?	?–?	Fairbanks-Morse	S.N. 4338. Water-cooled, five-passenger.

AUTOMOBILES

From 1917 to 1970, YVT purchased automobiles (mostly Fords) for its managers.

TRUCKS

A-2	1928–?	Chevrolet	S.N. 6LP2635
A-3	1927–?	Mack	S.N. 593593
A-4	1950–1970s?	Dodge	One ton. Purchased 1954.
A-5	1956–?	Chevrolet	?
A-6	1968–	Chevrolet	S.N. CE638J162120. Bucket truck. Operational.
A-7	1956–	International	S.N. 574056. Model S.C. 180.
A-8	1963–?	Ford	3-yard dump truck.

BUSES

B-1	1926–May 1948	Mack	First YVT bus. Started on Summitview line.
B-2	1926–May 1948	Mack	
B-3	1926–?	Mack	
B-4	Sept. 1940–Sept. 1952	Twin Coach	
B-5	Aug. 1940–Mar. 1953	Twin Coach	
B-6	Feb. 1942–Mar. 1957	Twin Coach	Sold to D. S. Peck
B-7	Feb. 1942–Mar. 1957	Twin Coach	Sold to D. S. Peck
B-8	Apr. 1946–Mar. 1957	Twin Coach	S.N. 91. Sold to D. S. Peck
B-9	Apr. 1946–Mar. 1957	Twin Coach	S.N. 92. Sold to D. S. Peck
B-10	Jan. 1947–Mar. 1957	Twin Coach	S.N. 338B. Sold to D. S. Peck
B-11	Jan. 1947–Mar. 1957	Twin Coach	S.N. 339B. Sold to D. S. Peck
B-12	Jan. 1947–Mar. 1957	Twin Coach	S.N. 340B. Sold to D. S. Peck
B-13	Jan. 1947–Mar. 1957	Twin Coach	S.N. 341B. Sold to D. S. Peck
B-14	June 1947–Mar. 1957	Twin Coach	S.N. 518B. Sold to D. S. Peck
B-15	June 1947–Mar. 1957	Twin Coach	S.N. 519B. Sold to D. S. Peck
B-16	June 1947–Mar. 1957	Twin Coach	S.N. 520B. Sold to D. S. Peck
B-17	July 1947–Mar. 1957	Twin Coach	S.N. 578B. Sold to D. S. Peck
B-18	1947–Mar. 1957	Twin Coach	S.N. 865B. Sold to D. S. Peck
B-19	1947–Mar. 1957	Twin Coach	S.N. 866B. Sold to D. S. Peck
B-20	1947–Mar. 1957	Twin Coach	S.N. 867B, Sold to D. S. Peck
B-21	Aug. 1952–Mar. 1957	Fageoliner	S.N. 22. Sold to D. S. Peck
B-100	?–?	Twin Coach	Leased from Boise Bus Company.
B-101	?–?	Twin Coach	Leased from Boise Bus Company.
B-102	?–?	Twin Coach	Leased from Boise Bus Company

S.T. = Single-truck trolley
D.T. = Double-truck trolley

S.N. = Serial number
STCP/Brill = Portugese streetcar builder for Oporto, using undercarriage components from Brill

INDEX

YAKIMA VALLEY TROLLEYS

The Yakima Valley Trolleys is a 501(c)(3) nonprofit organization whose volunteers run and maintain Yakima's trolley system. New members are welcome. Visit www.yakimavalleytrolleys.org for more information.

DISCOVER THOUSANDS OF LOCAL HISTORY BOOKS FEATURING MILLIONS OF VINTAGE IMAGES

Arcadia Publishing, the leading local history publisher in the United States, is committed to making history accessible and meaningful through publishing books that celebrate and preserve the heritage of America's people and places.

Find more books like this at
www.arcadiapublishing.com

Search for your hometown history, your old stomping grounds, and even your favorite sports team.

Consistent with our mission to preserve history on a local level, this book was printed in South Carolina on American-made paper and manufactured entirely in the United States. Products carrying the accredited Forest Stewardship Council (FSC) label are printed on 100 percent FSC-certified paper.

MADE IN THE USA